T0224996

SpringerBriefs in Architectural Design and Technology

Series Editor

Thomas Schröpfer, Architecture and Sustainable Design, Singapore University of Technology and Design, Singapore, Singapore

Indexed by SCOPUS

Understanding the complex relationship between design and technology is increasingly critical to the field of Architecture. The *Springer Briefs in Architectural Design and Technology* series provides accessible and comprehensive guides for all aspects of current architectural design relating to advances in technology including material science, material technology, structure and form, environmental strategies, building performance and energy, computer simulation and modeling, digital fabrication, and advanced building processes. The series features leading international experts from academia and practice who provide in-depth knowledge on all aspects of integrating architectural design with technical and environmental building solutions towards the challenges of a better world. Provocative and inspirational, each volume in the Series aims to stimulate theoretical and creative advances and question the outcome of technical innovations as well as the far-reaching social, cultural, and environmental challenges that present themselves to architectural design today. Each brief asks why things are as they are, traces the latest trends and provides penetrating, insightful and in-depth views of current topics of architectural design. *Springer Briefs in Architectural Design and Technology* provides must-have, cutting-edge content that becomes an essential reference for academics, practitioners, and students of Architecture worldwide.

More information about this series at https://link.springer.com/bookseries/13482

John Gales · René Champagne · Georgette Harun · Hannah Carton · Michael Kinsey

Fire Evacuation and Exit Design in Heritage Cultural Centres

 Springer

John Gales
Department of Civil Engineering
York University
North York, ON, Canada

René Champagne
Parks Canada Agency
Gatineau, QC, Canada

Hannah Carton
Department of Civil Engineering
York University
North York, ON, Canada

Georgette Harun
Department of Civil Engineering
York University
North York, ON, Canada

Michael Kinsey
Arup International Consultants Co., Ltd.
Shanghai, China

ISSN 2199-580X ISSN 2199-5818 (electronic)
SpringerBriefs in Architectural Design and Technology
ISBN 978-981-19-1359-4 ISBN 978-981-19-1360-0 (eBook)
https://doi.org/10.1007/978-981-19-1360-0

This Springer imprint is published by the registered company Springer Nature Singapore Pte Ltd.
The registered company address is: 152 Beach Road, #21-01/04 Gateway East, Singapore 189721, Singapore

Acknowledgements

Technical contributions are acknowledged from Timothy Young, Luming Huang, Julia Ferri, and Natalia Espinosa-Merlano. Previous contributions are acknowledged from Neir Mazur and Céleste Lalande. Chloe Jeanneret is thanked for supporting the project through copy-editing of the final manuscript.

Organizations thanked for their contributions include the Arup UK Fire Group, Arup North Americas Group, and Arup Human Behavior and Evacuation Skills Team. The Society of Fire Protection Engineering (SFPE) Foundation and MITACS are thanked for their financial support. The NSERC CRD programme is also acknowledged.

The Cultural Centre managers and event organizers, who remain anonymous, but granted permission for use of the cultural centre's recorded data are thanked for their time and assistance in this study.

Membership of the Interflam conference of 2019 is also thanked for providing recommendations and critical review of the research programme as a whole.

Carleton University is also thanked for providing ethics-based resources and institutional support for the data collection phase of this research project.

Contents

Chapter 1
Introduction to Fire Evacuation and Exit Design in Heritage Cultural Centres

1.1 Introduction to Fire and Human Behaviour

Fundamentals of human behaviour in fire are discussed to provide a basis for understanding the research study and results presented in this book. The reader is further directed to numerous primary sources and education materials which detail this subject [1–3]. Important principles are introduced and reviewed in this sub-section to place the following study and results into context.

Fire can be the building hazard that is least understood as it presents to people. The simplest explanation of fire dates to Victorian literature, *The Chemical History of a Candle*, by Michael Faraday. Faraday effectively demonstrated the fire process through the use of a candle in a series of laboratory lectures [4]. His demonstration involved the introduction of the 'Fire Triangle' commonly used as an explanation today. The Fire Triangle relies on the presence of a heat source, sufficient oxygen, and provision of fuel to explain most fire types. Through ignition, extinguishment, and re-ignition of a candle Faraday demonstrated principles of fire. He described that first the generation of heat to the candle by a "match or heat source" melts the wax on the candle's wick. The wax, in liquid form, then is drawn through the candle's wick, through a process known as capillary action, the liquefied wax then becomes a gas which then mixes with the surrounding oxygen from the air. With significant heat, the mixture of gas and oxygen begins a chemical reaction that generates more heat and gives off "light". The light emitted being the fire we recognize. Once either the oxygen or wax depletes the candle is demonstrated to burn out. Faraday explained that fire can further be understood by extinguishing the visible flame by smothering it. A smokey trail would emerge and he would introduce a heat source within the smoke. Instantaneously, the smoke would ignite and subsequently follow the trail of smoke to re-ignite the wick. It is the simplest expression to explain the science of a fire (fuel-heat-oxygen) to someone outside of the fire safety practice and still used today by fire services for training. The theory extends to understanding a room fire and the combustion by products that lead to tenability limits. Tenability limits are related to

J. Gales et al., *Fire Evacuation and Exit Design in Heritage Cultural Centres*, SpringerBriefs in Architectural Design and Technology, https://doi.org/10.1007/978-981-19-1360-0_1

the actual safe amount of time you have to leave a building. In Faraday's time, his lectures were closely linked to those from the fire service that exemplified the later. It was a form of early fire safety education to the general public and practitioners of the time.

This classic example of Faraday's fire visualization using a candle does not fully describe the hazard to buildings and occupants. However, within a building, the growth and size of a room fire are governed by similar principles of available fuel, air supply (ventilation), and the introduction of a heat source. Fire in enclosed spaces follow a specific growth in temperature with time as described in Fig. 1.1. That figure illustrates the evolution of a room fire (by heat released) with and without suppression by fire services or sprinkler systems. The fire is fuelled by the consumption of materials (furniture or other objects that act as fuel for the fire) in initial phases giving off heat in the form of energy to the rest of the room. This rapidly accumulates leading to flashover. Once flashover is achieved the fire is then controlled primarily by ventilation or influx of air into the room. It is assumed in the room fire that the evacuation of people is completed prior to the exponential increase in temperature in that room, or heat being released by the fuel—called flashover. Fire safety practitioners are concerned with this initial phase of fire to evacuate people before extreme temperatures emerge in an enclosed space. It is then subsequently important to understand and control the accumulation of smoke as a by-product of fire in these early stages. Tenability, rather survivability, is not only governed by the heat generated by the fire but also by the smoke of partially decomposed fuel in gaseous form in the building.

Occupants of buildings respond to emergencies, such as fires, in various ways. These vary from individual to individual based on many factors. Most existing building codes are built upon prescriptive assumptions such as travel distances, number of exits, etc. and subjected to inherent inclusion of behaviour within these codified values. These values are codified and generally influenced upon real fire case studies. The interpretation and following of these codes and standards are one of the most frequently utilized consultancy practices in fire safety [6]. The consultant

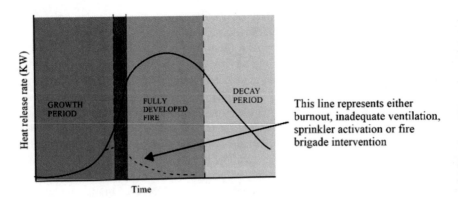

Fig. 1.1 Development of a fire's heat release in an enclosed room (as Adapted from Drysdale [5])

meets the requirements within the fire code which are assumed to provide adequate provisions for fire life safety. Provision of fire life safety is proportional to the uncertainty of the fire development, the structural response in early stages of fire, and human behaviour from the population responding to the emergency.

Code provisions in many cases were developed in response to major fires where life loss was large (Collingwood 1904, Iroquois Theatre 1903, Triangle Shirtwaist Factory 1911 as examples). The provisions were originally developed as prescription (egress times of two and half minutes or 45 m travel distances for example) [7] without actually quantifying specific behavioural influences. The first codes began to reflect behaviour inherent in the standard and document, and practice evolved to be prescriptive in nature. These almost entirely focus on specifying requirements for the physical parts and systems which form part of the building. At this time, building management and authorities with jurisdiction would complement these provisions by specifying requirements for conducting fire drills. The objective of these fire drills was to train specific human behaviour into the building's population [8]. The practicality of these early fire drills was of question for use as a training tool. Early critics noted potential adverse impacts: if drills were overused, if drills were not representative of emergency conditions, and if the building management did not participate fully as would be in a real fire situation. It was acknowledged, even then, that these drills could omit real behaviours seen in real emergencies [8]. Contemporary times began to show how unique human behaviours observed in real fires could be quantified and a provision of increased certainty could be provided in developed fire strategies and designs. This is in parallel to the development of tools for performance assessments that recognize the diversity in behaviour and the need for explicit representation. These innovations are being driven by significant case studies that begin to illustrate dominating behaviours that could be anticipated in design. The MGM Grand Hotel Fire for example was monumental in illustrating concepts of behavioural convergence clusters where in emergencies people gather for support [9]. This performance approach begins to move away from solely prescriptive guidance aiming to lower uncertainties in design.

Quite often when egress is considered, practitioners perform an ASET (Available Safe Egress Time) versus RSET (Required Safe Egress Time, the required time to egress). The procedure infers they quantify a set time for pre-evacuation and the evacuation process and compare this to the egress time before tenability limit (toxicity) conditions developed. Computational tools such as egress modelling may be used. If it can be shown that the population egresses in a specific time with a margin of safety the design is considered adequate. Fire code provisions commonly are based on a number of assumptions regarding people's behaviour including that people are aware of all available emergency exits, people will make full use of the available exits, people will start evacuating upon hearing a fire alarm, etc. [10].

Contemporary North American building codes typically prescribe specific exit requirements to prevent disproportionate use of one exit that would slow down egress. However, the assumptions used to create the prescriptive requirements do not fully account whether people evacuating are likely to behave in such a manner, as will

be illustrated in the Cultural Centre Case study below which forms the basis of the research study presented in this book.

1.2 Cultural Centre Case Study

This book reserves the identity of the building. Floor plans presented are modified so that the building and its location are anonymized herein.

In the fall of 2016, a manual fire alarm station was activated in the principal entrance of a North American Cultural Centre by a child. This action triggered an unplanned full evacuation of the building. Through a systematic review of the recorded closed circuit television camera (CCTV) footage, it was revealed that 73% of the 1730 occupants in the building utilized the principal (main) entrance for exiting during this evacuation. The remainder of the population utilized the 11 additional exits with no apparent preference or trend. This observed behaviour occurred despite the use of then code-compliant exit signage, personnel on site providing instructions, and physical barriers (horizontal sliding fire door assembly or known as a type of WON-door) which were meant to separate people in the building's eight exhibit wings from the four-level atrium. This physical barrier was also installed to prevent large use of the principal exit during an evacuation (see Figs. 1.2 and 1.3).

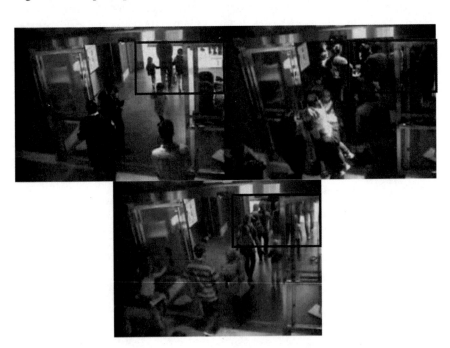

Fig. 1.2 Exhibit wing vestibule illustrating a WON-door (Closure, community dwell, then WON-door opening)

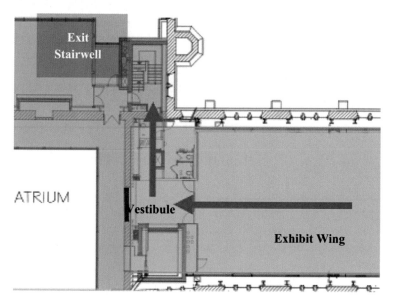

Fig. 1.3 Vestibule illustrating WON-door (Red line) and exit path by signage (Blue arrow)

As a result of the unplanned alarm event, the Building Executive of the Cultural Centre wanted to know what variables specifically affected the evacuation of visitors. In order to do so, they wanted to plan a series of full-scale unannounced evacuations (drills) with the underlining objectives to evaluate the behaviour of staff and provide quantifiable data to improve the building's overall fire safety and evacuation strategy.

These evacuations would be led by the Building Executive. The goals of the unannounced drill were to develop a baseline for the behaviour and actions of people during the pre-movement and movement stages of emergency egress situations and assess changes to be made to improve the overall fire safety plans, including the organization of designated staff for fire emergency purposes at the building. This was to ensure that the most efficient and best fit fire evacuation procedures and strategies would be set in place, using any and all safe evacuation methods available. The Building Executive also recognized that the collection of scientific data associated with this evacuation exercise could be beneficial in aiding the fire safety practitioner community with the decision process for egress and evacuation strategies—hence the authors' and associates' involvement in the study.

The Building Executive agreed that the information could be used towards a graduate thesis project (and in subsequent follow-up student projects) however, further analysis by the broader community, this book, would only follow once the challenges identified by the building were resolved.

As this was a National Cultural Centre, they were responsible and had a duty to make the premise reasonably safe. The authors and associate researchers entered a non-disclosure-agreement (NDA) for this phase of research, hence the publication of the case study much after the time of study (about 5 years). This agreement served to

protect the building, the researchers, and the occupants from any potential injuries. A final evacuation drill (again an annual unannounced drill) was held one year after the unplanned alarm event and previous evacuation drill. The purpose of this evacuation exercise was to assess the improvements in evacuation strategies and staff functions taken after the first drills as well as to verify building improvement in signage and way finding.

1.3 State of the Art in Human Behaviour in Fire

Prior to discussing the Cultural Centre case study and the recorded observations, it is necessitated that a relevant state-of-the-art theory in human behaviour in fire be explored and developed. This places remediation to the concerns addressed in the above scenarios in context and establishes the requisite overarching research objectives.

The National Building Code of Canada (NBCC), the authors' jurisdiction, has specific provisions that deal with exit requirements to limit the excessive use of one exit and to ensure egress in a timely manner [11]. Compliance with prescribed exit requirements is typically achieved through the combination of factors such as allowable travel distances, minimum width requirements for egress features (doors, stairwells, ramps) and calculated occupant loads. The use of additional exits while assuming a uniform distribution is a commonly accepted means to comply, as was the case in the above building. Generally, prescriptive requirements, like those found in Canada, assume rapid and simultaneous responses and that people move in a uniform manner of speed [12]. These assumptions do not always fully account for people's behaviour in evacuations and they may wrongly assume people behave competitively [12]. People are diverse in speed, altruism, socialization, and exhibit arrays of behavioural heuristics [13]. As the scenario above begins to illustrate, there is a need for designers to better understand building occupants so that evacuation design can accurately reflect realistic quantitative and qualitative occupant behavioural data.

Alternative solutions, in North American contexts, are typically approached through performance-based design that often requires the calculation of the Available Safe Egress Time (ASET), the time before conditions become untenable, and the Required Safe Egress Time (RSET), the time required for occupants to get to a place of safety. While the ASET and RSET approach has been established as an acceptable method to demonstrate a reasonable level of safety [14], it is imperative that building and emergency procedural designs accurately reflect realistic occupant behaviour during an emergency event [15]. Furthermore, this allows for the development of more representative computational tools (evacuation modelling) that accurately portray the expected behaviour of individuals while considering how they interact with others, or various groupings. However, a knowledge gap has appeared between new research and model development, which may be attributed to difficulty in translating results from experiments in valid predictions on human behaviour. In

many current evacuation models, the user is often required to set up the initial conditions and occupants' responses, which places a heavy burden on the user and their knowledge of human behaviour in fire [16].

The Society of Fire Protection Engineers (SFPE) recently identified critical fire safety research needs where human behaviour emerged as an important theme, with emphasis on obtaining behavioural data from diverse demographic and cultural populations [17]. Quantifying how people move within buildings during emergency evacuation is key in the design of buildings and infrastructure [18]. Meacham [19] posits that delays should be considered inherent when considering human responses to emergencies, as occupants take time to process and react to environmental cues, resulting in potential delays to recognize a fire threat and during an evacuation [19]. Modern building codes all consider occupancy as a key parameter for design requirements of a building, including the type of egress and exit system used [20]. Occupancy classifications in the National Building Code of Canada are based on assumed fire load, number of occupants, and ability of occupants to evacuate, but may not account for occupant behaviour during an evacuation. For example, with buildings intended for large gatherings of people for various purposes such as cultural centres [11], there are many factors that designers must consider. These factors include, but are not limited to, diverse demographic and cultural populations, high occupancy and varied occupant density, and occupant unfamiliarity with the building layout [20]. Diverse demographics such as those observed at cultural centres can have a significant impact on evacuations. Generally, one can assume people's walking speed decreases as they age and/or become less fit or are impacted by other physical abilities which may slow egress, such as challenges navigating stairs [21]. However, many datasets available are presented independently from the demographics they were collected from or are based on approximations instead of observed behavioural data [18]. Additionally, many datasets are based on old data which does not accurately represent the current population diversity and their movement abilities. With increasing populations of elderly and mobility-impaired people, implications for speed, as well as crowd density and flow should be considered [22]. Therefore, the collection of observed behavioural and movement data, especially of diverse cultural populations, is a recognized knowledge gap [17, 23].

A recent study, conducted by Larsson et al. [24], analyzed crowd flow, velocity, and density of exiting crowds in non-emergency situations at four different types of stadium events in England. The study found that crowd demographics had an observable impact on the aforementioned variables. A range of behavioural factors were identified as potentially influencing the egress observations, including but not limited to, population demographics and their innate velocities, density, propensity to form social groups, and other situational factors, such as the weather and time of day. Though highlighted, the study did not include an explicit investigation of human behavioural factors, underlying causes of demographic composition, or group behaviours, and called for future research on their impact on evacuations [24]. Concurrently, the study highlights the importance of studying different demographics and their egress, especially relevant to cultural centres. It also emphasized the need to continually update engineering tools and models as observed movement

profiles were significantly slower than those recommended within. Movement speeds in evacuation models are generally inputted as unimpeded walking speeds, where the user can select a distribution, which corresponds to a certain type of population or demographic. The unimpeded walking speed is often considered the maximum or desired walking speed which is only reduced in the face of physical obstacles or interferences. This assumption considers the desired walking speed as a function only of the person's physical abilities and the building's physical characteristics and does not fully consider or account for the person's motivation to move jointly with their physical abilities [25].

Recently, efforts have been made to characterize decision-making during emergency situations by other researchers. It has been found that actions taken in a situation are the result of a decision-making process, as opposed to directly from a stimulus or random chance [26]. The Protective Action Decision Model (PADM) is one behavioural framework that attempts to describe the pre-decisional and decisional sequences of action making during emergency situations [27]. The PADM asserts that protective action decision-making is initiated by first receiving environmental cues. After the cue is received, it is processed and evaluated by the individual to determine the risk credibility and appropriate action. Following the risk assessment, the individual evaluates protective actions that are available to them. Throughout the process, the individual may evaluate information-seeking actions [27]. Research has also been ongoing as to how cognitive biases, defined as systematic deviations from normal judgement using inferences, effect the decision-making process, as well as how they may be considered within the PADM framework. Notably, a list of cognitive statements that may influence decision-making during an evacuation has been compiled. There are many examples of cognitive biases. One relevant to the case study herein is the default effect, defined as "the tendency to follow a default option" [13], which was observed in the evacuation of the Cultural Centre false alarm, as the majority of occupants chose the main exit as their egress route. Mitigating measures to the potential cognitive biases have also been proposed, however, the cognitive biases identified have not been specifically studied in a fire engineering setting and require validation [28].

Studies have found that emergency signage plays a role in influencing decision-making and exit choice for individuals, however, it is dependent on how the individual perceives the sign. A study by Xie [29] found that only 38% of individuals detect conventional static exit signs, however, those that do notice the exit sign comply with the directions and take less time to make an exit decision than those that do not [29]. The study was later replicated and found that by adding a dynamic element to the exit signs, in the form of a flashing arrow, the detection rate rose to 77%. As with the conventional static exit sign, those who perceived the dynamic exit sign also complied with the directions on the sign and had a shorter decision time [30]. In addition to dynamic exit signs, colour has also been found to influence the effectiveness of an exit sign. In a virtual reality (VR) study performed in the United States, which examined the impact of colour on exit choice, it was found that individuals primarily chose the exit marked with a green sign. However, in a post-experiment survey, when asked what colour an exit sign should be, the majority of the respondents chose

red, possibly due to their familiarity to this colour being used historically according to state law. The differences in behaviour versus survey response, emphasizes the importance of experimental behavioural studies, as anticipated behaviours may not occur as expected [31].

In addition, emerging research has proposed that in the context of mass gatherings, decision-making may be influenced by social identity [32]. It implies that during an emergency, collective (shared) decision-making can occur. A virtual reality (VR) study done on exit choice in 2018 by Kinateder et al. observed that participants were more likely to choose a familiar exit over an unfamiliar exit. They also observed that the participants were more likely to use the exit that a virtual neighbor used. The exit familiarity and neighbour behaviour effects were observed to interact through either reinforcing choosing the familiar exit, or negating it when neighbours used unfamiliar exits [33]. A recent experimental laboratory study examining evacuation behaviour of individuals in groups of 5 or 12–13 people versus a single individual found similar results, where participants who evacuated in a group all used the same exit. It also found that participants in a group of 12 were faster to start to evacuate than an individual, however, the time difference between a group of five and an individual was not statistically significant [34]. A different study examining unannounced evacuations in large retail stores found that the staff played a large role in evacuations as they acted as the emergency cue to evacuate for many of the occupants. The staff also played a role in guiding the exit choices of the visitors; however, underlying behaviour and the decision process was not examined [35]. Staff guidance has also been observed to be the most effective way of decreasing delayed evacuation responses from occupants after a review of real-world evacuation videos [36].

1.4 Research Objectives

Human behaviour has been identified as a critical research need in order to improve the safety of a building through informing design and emergency policies. Following the evacuation scenario presented and comprehensive background analysis of contemporary human behaviour studies, the authors continued the study of cultural centres analyzing the first unplanned evacuation, followed by the consideration and analysis of two subsequent annual evacuation drills at the same building. This research study aims to:

- Describe and document the evacuation events drills performed over two years at the Cultural Centre (Chap. 2);
- Develop a baseline for the behaviour and actions of people during the premovement and movement stages of emergency egress situations (Chap. 3);
- Collect behavioural and movement profile data to aid the fire safety engineering community with the decision process for egress and evacuation strategies (Chap. 3);

- Interrogate and highlight architectural barriers in heritage structures with respect to emergency evacuation using computational tools (Chap. 4);
- Present strategies used in the Cultural Centre for effective exit usage through staff training and improved signage (Chap. 5); and
- Describe the future outlook for human behaviour in fire research (Chap. 5).

Closed circuit television camera (CCTV) footage from the Cultural Centre was analyzed from three separate unannounced evacuations. Based on the first two evacuations changes were made to the fire strategy (signage and staff training) and these were implemented before the third evacuation. The findings from the study are intended to inform the development of evacuation modelling tools which can more accurately represent the behavioural patterns observed and lower uncertainty in design.

This research project was part of a larger foundational study by the authors and their collaborators. The study considered various infrastructure and building types across Canada (transit terminals, stadiums, care homes). The undertaken study aimed to quantify the behaviour and movement of modern demographics and populations. The research was supported by the SFPE Foundation, NSERC Canada and the authors' industry collaborators Arup [18].

1.5 Case Study Building Architecture and History

The Cultural Centre herein primarily acts as a museum, but also hosts special events such as a monthly dance venue, weddings, receptions, birthdays, and conferences. These all have distinct flow patterns and density of occupants. Its current function serving as a museum, will be the focus herein. The building was constructed in the early twentieth century and was designated a heritage building due to its historical and architectural significance. At the time of study, the building had a maximum design occupancy of 4184 people. It is four storeys in building height and includes two sub-grade levels. The public can access part of the first sub-grade, which includes a theatre and children's lab/play area, as well as all four above-grade levels during regular business hours. The subgrade levels are served by ten exits leading to the ground floor. Floors two to four are served by six exits leading to the ground floor. The ground floor is served by 12 exits. Common floor geometries are presented in Fig. 1.4.

When considering emergency egress in heritage buildings, there are often adjustments needed to the original egress routes to comply with contemporary building codes, while simultaneously respecting the heritage value of the structure and minimizing interventions to heritage character defining elements. An understanding of the unique features of heritage buildings and their effect on emergency egress is needed to evaluate and improve the performance of the building beyond prescriptive requirements. Most heritage designated buildings are historic, so research on either

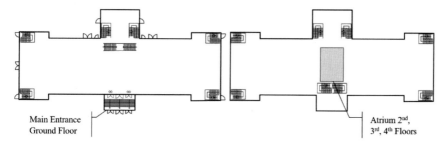

Main Entrance
Ground Floor

Atrium 2nd,
3rd, 4th Floors

Fig. 1.4 Ground floor and 2nd, 3rd and 4th floor general layout

heritage or historic buildings are all applicable to heritage building's emergency egress performance.

Heritage buildings are often visited by those who are unfamiliar with the layout, such as cultural centres as is presented herein (frequently visited by tourists). This can contribute to higher pre-movement times during evacuation as the occupants seek more information before egress and rely on specific verbal cues from staff or voice alarm systems [37]. Human behaviour considerations, such as decision-making, wayfinding, and movement speeds can also be affected by social and cultural backgrounds of occupants. This is important to note as heritage cultural can centres typically host a diverse group of occupants compared to other buildings [38]. Additionally, the diverse occupants have diverse linguistic abilities which also affect movement times based on verbal evacuation cues [39]. Heritage buildings can tend to have more complex layouts than contemporary buildings, as well as relying on fewer main entrances, with many secondary exits for egress that are unfamiliar to and often ignored by occupants.

Heritage buildings tend to have a greater variety of corridor and doorway widths compared to modern buildings, which will have an effect on egress performance. For example, narrower passages are more likely to lead to occupant overcrowding and bottlenecks, and the opposite is true for wider passages. The visibility and position of egress routes are also not always ideal in heritage buildings because they were not considered in the original design, and alternate egress routes to the main entrances were often not included entirely [37]. This is due to the construction of most heritage buildings preceding the introduction of maximum egress distances in building codes, which were not introduced before the 1920s in most countries, and the first building code in Canada was only introduced in 1940 [40, 41]. Egress routes are therefore added during renovations of heritage buildings, to meet prescriptive code requirements.

These specific challenges to egress in heritage buildings must be considered in evacuation data and egress modelling, but there is only limited associated data from heritage buildings, and most is dated from the 1950–80s [22]. Egress models for heritage buildings that do not consider their unique features are limited in their ability to evaluate performance and could result in unconservative predicted egress times [42]. Beyond life safety goals, heritage cultural centres often house irreplaceable

cultural items, and their safe removal may be included in the emergency egress plan and therefore complicating exit and egress strategies [43].

Many of these challenges have been highlighted in fire risk analyses for heritage buildings, but the analysis rarely translates to tangible design solutions that consider the inherent features of heritage buildings such as wide passages and high ceilings (both present in the building presented herein) [40]. Wide passages can mitigate the formation of bottlenecks during evacuation, and high ceilings can limit the occupant's interaction with smoke and extreme heat during egress [40]. Modelling and calculations are needed to demonstrate the safety for occupant egress for each individual historic building, but an understanding of heritage architectural features (present in heritage buildings) can contribute to building safety outside of code compliance.

In the early 2000s, the Cultural Centre considered herein underwent a large-scale rehabilitation project which added a new glass tower to its façade and undertook major interior modifications, which permitted it to expand on its services to the public and enhance the visitor experience. These interventions have a variety of effects on the emergency egress, whether improving performance or not. The most significant feature was the addition of a glass tower containing scissor stairs at the front of the building. These stairs were added to provide additional connection between the second and fourth floors, which were historically intended not to be accessible to the public. In addition to the new staircase, ten emergency exits were added to the various corners of the building, in an attempt to facilitate emergency egress to modern code compliances on number of exits. Another aspect of the renovations under consideration is the support columns for the new glass tower, which are placed very close to two of the three entrance doors, and a wheelchair elevator.

Prior to the commencement of this study, it was found that during regular ingress and egress the centre door (not blocked by columns) is the one predominately utilized. During emergency egress, the two side doors can be useful for evacuating the main entrance, but as seen in the aforementioned false alarm scenario, over 70% of occupants exited here. Figure 1.5 renders the floor geometry of the main entrance from a real image to preserve the building's anonymity.

1.6 Ethics and Related Limitations

Two specific events that occurred in the Cultural Centre raised concerns with the Building Executive as to the safety of the visitors during an incident requiring an evacuation. The first event was the activation of a manual station by an occupant while the building was being used as a dance venue (with approximately 4184 visitors). An occupant had wanted to smoke without having to leave the building, triggering another occupant to activate the manual station at full occupancy of the building. Although not much information was provided from this event for this study, the building management modified several of their strategies and increased security staff to address some of the perceived gaps identified during this incident. In a separate

Fig. 1.5 Main exit architecture as artistically rendered to preserve anonymity

incident which followed months later, a manual station was activated by an unattended child in the west vestibule area of the main entrance. For an unexplained reason, the fire alarm system transferred to second stage (verbal-audio) within 2 min and 18 s of the initial alarm (sound and light) being activated and caused a complete evacuation of the building. Approximately 1730 visitors were present at the time of the alarm. Upon second stage alarm activation, the elevators were recalled to the ground floor, the air handling units shut down, some of the pressurization fans activated and the eight accordion-type horizontal sliding fire doors (WON-Doors) released and closed access to the atrium from the wings and hall at each upper floor level. The activation of these WON doors created an unforeseen challenge, as neither the security staff nor the visitors could discern how to exit the floor area once the main entrance to the floor area was blocked. Once the visitors discovered that the WON doors could be partially opened manually, they were able to gain access to the atrium area and subsequently most occupants (> 70%) exited the building through to the main entrance.

As a result of the events mentioned above, the executive management and security office desired to know what variables specifically affected the evacuation of visitors. Collecting behavioural data in real emergency situations is difficult due to ethical restrictions, notably, difficulty of quantifying the risk versus the benefits, as well

as allowing for informed consent by the participants [44]. The Building Executive subsequently wanted to utilize video recordings of their mandatory and annual unannounced evacuations and previous recorded situations to collect this data. Data would be collected from footage captured with the existing video surveillance system that is installed for the protection of the video collection and for security reasons. It was established to attendees in the building that filming is always in progress and that there is no reasonable expectation of privacy for the person in the subject building.

The Building Executive's goal was to develop a baseline for the behaviour and actions of occupants and staff during the pre-movement and movement stages of emergency egress situations. This was to improve the overall fire safety plans including the organization of designated staff for fire emergency purposes in the building and ensure that the most efficient and best fit fire evacuation procedures and strategies are set in place, using any and all safe evacuation methods available. This was a mandatory objective to the building to follow. The evacuation exercises would receive support from the authorship team. The authors would later analyze and interpret the recorded video footage of the drills and previous events for the Building Executive.

The subsequent evacuation exercises were fully directed and controlled by the building directors and the Chief of Protection. The Building Executive also recognized that the collection of scientific data associated with this evacuation exercise could be beneficial in aiding the engineering and architectural community with the decision process for egress and evacuation strategies in heritage buildings and cultural centres. They agreed that the analysis and information collected could be used towards a graduate thesis project of the researchers. An agreement was prepared and approved by the Cultural Centre, its directors, the researchers, and their ethics office which detailed the limitations of the study and fundamentally protected the building, the researchers, and the occupants from any potential liability or injuries. The researchers' institution complied with the sensitive nature of the project and agreed to the terms of the Cultural Centres' agreement, data collection, analysis protocols, and conduct plan. At this time, the institutional ethics were approved using the documentation of the Cultural Centre's agreement between both parties. Examiners of the graduate student theses were to also bound to confidentiality during the time where the agreement was in place. Further analysis (in the form of this book, and other related presentations) by the broader community, were only permitted once the challenges identified by the Building Executive were resolved. All parties involved in the study and exercises entered this agreement for this phase of research, which was relaxed after several years in 2019 where it became evident that these challenges were resolved and that other cultural centres could benefit from the results of, and the methodologies developed in the study within certain limitations explored herein. As part of the agreement, the security incident reports detailing Guards' observations during the emergency evacuations as well as the footage of the occupants of the Cultural Centre was to be translated into non-identifiable information, and all digital video files were to be destroyed or returned to the building at project's final completion. The study would be restricted to utilizing only previously recorded evacuation footage, and footage of two mandatory annual egress drills to be held in the autumn

season. Subsequently, this book omits certain identifiable markers of the Cultural Centre to preserve its anonymity.

It is important to note that the annual egress drills were the researchers' only option for quantitative data collection and modelling validation in this project. It is understood that this methodology and data collection will be subject to limitations in utility and credibility. Egress drills are one method of many to assess the behaviour of occupants, staff, and authority figures under emergency scenarios, and in most cases, without any real danger or consequences from a fire or its by-products. They can be considered an acceptable mid-point between laboratory (controlled environment) and full field settings [45]. Egress drills have been used historically as a method to fulfil research objectives. Conducting effective egress drills helps building owners and others responsible for fire safety within a building to provide opportunities for comprehensive fire emergency response training for supervisory staff, and also to assess the ongoing effectiveness of the emergency procedures under different scenarios and conditions. Although it may appear as a simple model of evacuation, egress drills are a critical tool for observing occupant and staff behaviours and for measuring evacuation performance. However, considerations must be made in order to enhance the utility and credibility of the information gathered during the drill, not only for observation purposes but also as a way to train occupants and staff on evacuation procedures [46]. The use of egress drills for scientific data collection and validation purposes can be limited as they typically do not reproduce real-life scenarios accurately through introducing urgency and/or restrictions that pose a risk to the participants, such as stress/anxiety. This, unfortunately, may cause increased potential for injury to participants. There are also procedural limitations to performing large-scale evacuations as it may not be possible to have sufficient instrumentation or research staff available for data collection without influencing the participants [46]. Egress drills can be considered by fire safety experts to have credibility when compared to other simulation methods such as immersive technology methods. However, egress drills can be also considered by experts to be less able to provide potential insights on reality and subjected to limitations on their overall credibility [47]. While egress drills by some are considered costly, in this study costs were minimized as existing surveillance cameras were used and admission to the Cultural Centre was free the night of the annual egress drills. Participants did not need to pay for tickets to the venue and reimbursements were not required. In many other cases, without proper considerations, drills can indeed be costly and operationally disruptive. Alternative methodologies can range from laboratory settings such as virtual reality (VR) and hypothetical choice experiments, to field settings such as post-disaster interviews/surveys and analysis of natural disasters. In general, laboratory studies can be found to have more control of variation and responses, as well as greater reproducibility, however, they lack contextual and ecological validity. Field studies, by contrast, have much less control over variation and responses, and as such, are more difficult to reproduce on a consistent basis. They are however, considered much more realistic [45]. Ideally a combination of methods can yield an optimum result, however limitations in agreement, timelines, and available resources prevented the use of multiple methodologies for validation purposes in this study.

1.7 Book Summary

The book was divided into several narratives which build upon each other to meet the research objectives as defined in Sect. 1.4. This first chapter has introduced various aspects of the field of study to introduce the reader to the case study and relevant literature. The research is established in its use and novelty.

This chapter herein provided the reader with contextual background and reference to appropriate theory as well as framing the motivation and goals of this book.

Chapter 2 will explain the data collection methodology and provide an overview of the three evacuation scenarios considered in the Cultural Centre.

Chapter 3 will develop a baseline for the behaviour and actions of occupants during the pre-movement and movement stages of each evacuation scenario. Movement profile data will be presented to aid the fire safety engineering community with the decision process for egress and evacuation strategies.

Chapter 4 will consider the architectural barriers in heritage structures with respect to emergency evacuation using computational tools.

Chapter 5 will present fire safety evacuation strategies that will be used in the Cultural Centre for effective exit usage through staff training and improved signage. The chapter will conclude with describing the future outlook for human behaviour in fire research.

As per the study of the real building, this book has reserved recommendations to the overall fire safety plans for all buildings of similar type as specific insights are based upon the specific building considered herein. It is however a foundational reference for building studies or those which encounter similar issues and require a starting point for discussion. It is not intended that the book be used for code development nor application in all buildings of similar construction and use.

References

1. Society of Fire Protection Engineers, SFPE handbook of fire protection engineering, 5 ed. by M.J. Hurley (Springer, New York, 2015)
2. Society of Fire Protection Engineers, SFPE guide to human behavior in fire, 2 ed. (Springer, 2019)
3. J. Gales, L. Folk, C. Gaudreault, The study of human behavior in fire safety engineering using experiential learning, in *7th Canadian Engineering Education Association's Annual Conference* (Halifax, 2016)
4. J. Gales, Charles dickens and fire science. Fire Technol. **51**, 749–752 (2015)
5. D. Drysdale, *An Introduction to Fire Dynamics* (Wiley, Chichester, 2011)
6. B.J. Meacham, Risk-informed performance-based approach to building regulation, in *7th International Conference on Performance-Based Codes and Fire Safety Design Methods* (Auckland, 2008)
7. Anon, *Fire Safety: Approved document B. Building Regulation in England Covering Fire Safety Matters Within and Around Buildings* (2020)
8. L. Bryant, Fire drills and fire protection, in *Second Safety Congress of National Council for Industrial Safety* (1913)

9. J.L. Bryan, A review of the examination and analysis of the dynamics of human behavior in the fire at the MGM Grand Hotel, Clark County, Nevada as determined from a selected questionnaire population. Fire Saf. J. **5**(3–4), 233–240 (1983)

10. N.B.N.S.M. Kinsey, A review of human behaviour assumptions within UK building fire design guidance, in *Conference: Sixth International Symposium on Human Behaviour in FireAt: Downton College* (Cambridge, 2015)

11. Canadian Commission on Building and Fire Codes and National Research Council of Canada (NRC), *The National Building Code of Canada* (NRC, Ottawa, 2015)

12. S.M.V. Gwynne, The unintended consequences of ignoring evacuee response, in *Fire and Evacuation Modeling Technical Conference (FEMTC)* (Gaithersburg, MD, USA, 2018)

13. M.J. Kinsey, S.M.V. Gwynne, E.D. Kuligowski, M. Kinateder, Cognitive biases within decision making during fire evacuations. Fire Technol. **55**, 465–485 (2019)

14. E.D. Kuligowski, S.M.V. Gwynne, M.J. Kinsey, L. Hulse, Guidance for the model user on representing human behavior in egress models. Fire Technol. **53**(2), 649–672 (2017)

15. S. Gwynne, *Conventions in the Collection and Use of Human Performance Data*, February 2010. [Online]. Available: https://www.nist.gov/system/files/documents/el/fire_rese arch/NIST_GCR_10_928.pdf

16. E. Ronchi, A. Corbetta, E.R. Galea, M. Kinateder, E. Kuligowski, D. McGrath, A. Pel, Y. Shiban, P. Thompson, F. Toschi, New approaches to evacuation modelling for fire safety engineering applications. Fire Saf. J. **106**, 197–209 (2019)

17. SFPE, *Research Needs for the Fire Safety Engineering Profession: The SFPE Roadmap*, 21 June 2018. [Online]. Available: https://cdn.ymaws.com/www.sfpe.org/resource/resmgr/roa dmap/180703_SFPE_Research_Roadmap.pdf

18. J. Gales, J. Ferri, G. Harun, C. Jeanneret, T. Young, M. Kinsey, W. Wong, S. Jared, L. Chen, *Anthropomorphic Data and Movement Speeds*, 6 May 2020. [Online]. Available: https://cdn. ymaws.com/www.sfpe.org/resource/resmgr/foundation/research/gales_report.pdf

19. B.J. Meacham, Integrating human behaviour and response issues into fire safety management of facilities. Facilities **17**(9/10), 303–312 (1999)

20. R. Champagne, T. Young, J. Gales, M. Kinsey, Fire evacuation and strategies for cultural centres, in *15th International Conference and Exhibition on Fire Science and Engineering* (Egham, UK, 2019)

21. M. Spearpoint, H.A. MacLennan, The effect of an ageing and less fit population on the ability of people to egress buildings. Saf. Sci. **50**(8), 1675–1684 (2012)

22. P. Thompson, D. Nilsson, K. Boyce, D. McGrath, Evacuation models are running out of time. Fire Saf. J. **78**, 251–261 (2015)

23. M. McNamee, B. Meacham, P. van Hees, L. Bisby, W.K. Chow, A. Coppalle, R. Dobashi, B. Dlugogorski, R. Fahy, C. Fleischmann, J. Floyd, E.R. Galea, M. Gollner, T. Hakkarainen, A. Hamins, et al., IAFSS agenda 2030 for a fire safe world. Fire Saf. J. **110** (2019)

24. A. Larsson, E. Ranudd, E. Ronchi, A. Hunt, S. Gwynne, The impact of crowd composition on egress performance. Fire Saf. J. (2020)

25. E. Ronchi, Developing and validating evacuation models for fire safety engineering. Fire Saf. J. (2020)

26. E. Kuligowski, Predicting human behaviour during fires. Fire Technol. **49**(1), 101–120 (2013)

27. L.H. Folk, E.D. Kuligowski, S.M. Gwynne, J.A. Gales, A provisional conceptual model of human in response to wildland-urban interface fires. Fire Technol. **55**(5), 1619–1647 (2019)

28. M.J. Kinsey, M. Kinateder, S.M.V. Gwynne, D. Hopkin, Burning biases: Mitigating cognitive biases in fire engineering. Fire Mater. (2020)

29. H. Xie, *Investigation into the interaction of people with signage systems and its implementation within evacuation models* (University of Greenwich, London, UK, 2011)

30. E.R. Galea, H. Xie, P.J. Lawrence, Experimental and survey studies on the effectiveness of dynamic signage systems. Fire Saf. Sci. **11**, 1129–1143 (2014)

31. M. Kinateder, W.H. Warren, K.B. Schloss, What color are emergency exit signs? Egress behavior differs from verbal report. Appl. Ergon. **75**, 155–160 (2019)

32. J. Drury, The role of social identity processes in mass emergency behaviour: An integrative review. Eur. Rev. Soc. Psychol. **29**(1), 38–81 (2018)
33. M. Kinateder, B. Comunale, W.H. Warren, Exit choice in an emergency evacuation scenario is influenced by exit familiarity and neighbor behavior. Saf. Sci. **106**, 170–175 (2018)
34. A. Cuesta, O. Abreu, A. Balboa, D. Alvear, Alone or with others: Experiments on evacuation decision making. Fire Saf. J. (2020)
35. T.J. Shields, K.E. Boyce, A study of evacuation from large retail stores. Fire Saf. J. **35**, 25–49 (2000)
36. C.N. van de Wal, M.A. Robinson, W.B. de Bruin, S. Gwynne, Evacuation behaviors and emergency communications: An analysis of real-world incident videos. Saf. Sci. **136** (2021)
37. G. Bernardini, *Fire safety of historical buildings. Traditional versus innovative "Behavioural Design" solutions by using Wayfinding Systems* (Springer, 2017)
38. U. Chattaraj, A. Seyfried, P. Chakroborty, M.K. Biswal, Modelling single file pedestrian motion across cultures. Procedia. Soc. Behav. Sci. **104**, 698–707 (2013)
39. N. Mazur, R. Champagne, J. Gales, M. Kinsey, The effects of linguistic cues on evacuation movement times, in *15th International Conference and Exhibition on Fire Science and Engineering* (Windsor, UK, 2019)
40. J.L. Torero, Fire safety of historical buildings: principles and methodological approach. Int. J. Architectural Heritage **13**(7), 926–940 (2019)
41. National Research Council of Canada, *National Building Code* (National Research Council of Canada, Ottawa, 1941)
42. E. Carattin, V. Brannigan, Controlled evacuation in historical and cultural structures: requirements, limitations and the potential for evacuation models, in *Proceedings of the 5th International Symposium on Human Behavior in Fire 2012* (London, 2012)
43. J.E. Almeida, R.J. Rossetti, A.L. Coelho, The importance of prevention and emergency planning in cultural buildings. Cult. Heritage Loss Prev. 47–54 (2014)
44. K. Boyce, D. Nilsson, Investigating ethical attitudes in human behaviour in fire research, in *6th International Symposium on Human Behaviour in Fire* (Cambridge, UK, 2015)
45. M. Haghani, M. Sarvi, Crowd behaviour and motion: empirical methods. Transp. Res. Part B Methodological **107**, 253–294 (2018)
46. S.M.V. Gwynne, E.D. Kuligowski, K.E. Boyce, D. Nilsson, A.P. Robbins, R. Lovreglio, J.R. Thomas, A. Roy-Poirier, Enhancing egress drills: preparation and assessment of evacuee performance. Fire Mater. **43**(6), 613–631 (2017)
47. S. Gwynne, M. Amos, M. Kinateder, N. Bénichou, K. Boyce, C. N. van der Wal, E. Ronchi, The future of evacuation drills: Assessing and enhancing evacuee performance. Saf. Sci. **129** (2020)

Chapter 2
Data Collection for Evacuations of a Heritage Cultural Centre

2.1 Introduction

Three evacuation scenarios of a Cultural Centre in Canada were documented and considered. The first scenario (Scenario 1) represents an unplanned evacuation during the day where an emergency pull station was activated by an occupant. The next scenarios (Scenarios 2 and 3) were annual evacuation drills held over the course of two years. These annual drills were held on days where admission was free to the occupants. Scenario 3 featured implementation of changes to signage and staff training to improve the exit use and egress efficiency. All scenarios are described herein. It is critical to remark that all scenarios can be considered evacuation drills. Neither the staff nor the occupants were informed to the nature of the emergency.

The Cultural Centre operates under a two-stage alarm process (see Sect. 2.4). The first stage, or alert, is a non-continuous chime (bell), strobe light, and feminine voice to enable the occupants to be alert of a potential hazard. The second stage, or alarm, is a feminine voice alert to evacuate, strobe light, and continuous bell to notify occupants to evacuate. Data was collected in both stages. This is because it was observed in all scenarios that a portion of occupants evacuated in the first alarm stage. Staff and visitors were uninformed to the nature of the evacuation prior to all scenarios.

This section explores the scenario introduction and the data collection process. The specific behavioural and movement actions are presented in the later portions of this book.

2.2 Methods of Data Collection

A qualitative analysis was performed for the Scenario 1 evacuation event by reviewing approximately 398 min of footage provided through 44 CCTV cameras. The CCTV

J. Gales et al., *Fire Evacuation and Exit Design in Heritage Cultural Centres*,
SpringerBriefs in Architectural Design and Technology,
https://doi.org/10.1007/978-981-19-1360-0_2

cameras were not optimally aligned or in specific focus, so the footage was only valuable for behavioural analysis in a qualitative sense and exit use in a quantitative sense (the authors manually counted the number of people emerging from each ground exit with time from the second stage).

A qualitative and quantitative analysis was performed for the Scenario 2 evacuation event by reviewing 448 min of footage provided through 47 CCTV cameras. A total of 260 h by the authorship research team was spent to analyze footage to collect data for this scenario. A likewise analysis of Scenario 3 was not possible due to these timing constraints. The CCTV cameras do not record sound. Prior to the evacuation drill, a comprehensive review of the cameras was performed to determine the angle of view and sight lines that would permit the best overall coverage of each floor area and exits. Four of the CCTV cameras were malfunctioning during the time of the exercise. This resulted in some areas on the floors having little to no coverage. To compensate for this deficiency in coverage, several temporary cameras were installed throughout the building. The resolution of this footage was much higher than that of the CCTV films and included sound. The additional feature of the installed cameras was important to establish a proper timeline and sequence of events. Information on 347 of the 457 occupants was collected through a thorough analysis of the CCTV footage. The remaining occupants could not be tracked fully through the building. Each individual was tracked from origin at the commencement of Stage 2 of the alarm to their eventual egress through manual plotting as is shown in Fig. 2.1. Manual plots have subsequently been adapted following similar notation styles as described by Gwynne et al. [1]. Agent data was then compiled in a comprehensive behavioural database as illustrated in Table 2.1 for later modelling usage and future research.

Recognizing some subjectivity in categorizing ages, three researchers repeated the analyses presented with minimal differences. Sorting of individuals followed this procedure: people were broken into five separate age categories (under 3 "Tiny Tots", 3–12 "Kids", 13–17 "Teenagers", 18–65 "Adults", over 65 "Seniors"). These categories were selected to match those being used by the buildings marketing database and later, conformance of demographics was compared to those as officially recorded at the Cultural Centre (ticketing) as having entered with minimal differences. Occupants are still ticketed even if admission is free. Every person identified as a "tiny tot" was seen in a stroller, in a carrier, or very small and walking in a limited capacity during the time period between first and second stage alarms. A limited capacity was defined as requiring assistance (hand holding) or holding on to objects or propping themselves up for a brief period. When the second stage alarm was initiated the "tiny tots" that were initially identified were re-classified as a child (3–12) if they were observed leaving the building on their own accord and capable of dressing themselves (putting on their jackets and tuques). The authors recognize that there will always be some degree of subjectivity in categories without a specific survey of the population (which was not possible due to ethical restraints in this procedure) [2].

The current procedure allowed the authors to later develop movement profiles specific to those categories as would be seen in Chap. 4 using specific software. Egress was considered unimpeded in most cases where movement speeds were derived. This was based upon population densities where free flow would be observed. It is of note

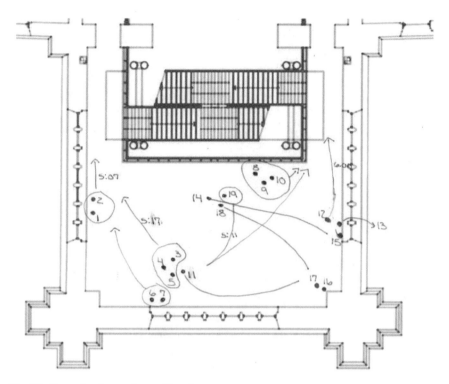

Fig. 2.1 Example of manual record keeping

Table 2.1 Occupant database criteria

Criterion
• Occupant identifier number
• Age demographic
• Group travel (y/n)
• Travelling with (Occupant identifier number)
• Number of people in group
• Floor number
• Floor location at first stage alert
• Floor location at second stage alarm
• Jacket (y/n)
• Observations

in Scenarios 2 and 3, the occupancy of the building was near 10% in both scenarios. Future research will need to explore higher volume considerations. The database allows future extraction for impeded movement once software for data extraction improves as is being planned by the author's research team.

The planning of the Scenario 3 evacuation was conducted in the same manner as Scenario 2 (staff and visitors were uninformed, for example). A qualitative analysis was performed for the evacuation event, similarly to Scenario 1. In this case only exit use was considered in a quantitative sense (the authors manually counted the number of people exiting from each exterior door and noted the time after second stage alarm initiation). Unlike Scenario 2, movement profiles of this scenario were not generated. The purpose of Scenario 3 was to assess staff, monitor exit usage, and evaluate how the changes implemented after the first planned evacuation drill affected results.

2.3 Scenario 1—Unplanned Evacuation

The first full evacuation event, referred to as Scenario 1, was an unplanned full evacuation of the Cultural Centre. The event was recorded by CCTV cameras and provided to the authors in preparation for a planned annual evacuation drill (Scenario 2). A fire alarm was initiated from the activation of a manual station by a child in the west vestibule area of the main entrance. This incident occurred in the afternoon during early autumn.

The automatic transfer to the second stage alarm resulted in a complete evacuation of the building. Approximately 1730 visitors were present at the time of the alarm inclusive of 16 staff. Upon activation of the second stage alarm, safety provisions were invoked as per the prescribed procedures. However, the activation of the WON-doors created an unforeseen challenge as neither the security staff nor the visitors appeared to know what they should do and how to exit the floor area once the main entrance to the floor area was blocked. In recorded video footage, it was observed that the visitors gained access to the atrium area as it observed that they figured that these doors could be opened manually and proceeded to force them open. Once in the atrium, they exited the building through the main entrance. This represented a population greater than 70%.

2.4 Scenario 2—First Planned and Unannounced Annual Drill

The building's exit facilities and current evacuation procedures and strategies were reviewed prior to performing the annual planned evacuation drill (Scenario 2). This included a comprehensive review and evaluation of the evacuation routes and exit

facilities with specific focus on the following conditions: clearly marked and well lit, wide enough to accommodate the number of evacuating personnel, unobstructed and clear of debris, and unlikely to expose evacuating occupants to additional hazards.

The building's emergency response plans and posted emergency evacuation plans, which include a primary and secondary path of travel, were also reviewed. This allowed the researchers to gain an understanding of the staff's roles and responsibilities during an evacuation and the desired behavioural responses from occupants. The information contained within these documents were used to compare the expected behaviours with those witnessed during the evacuation drill.

A planned unannounced evacuation drill was conducted on a Thursday evening in the autumn. Thursdays are typically the busiest days of the week as free admission is provided after 17:00. As part of the ethics protocol in the study it was decided to offer free admission vouchers to occupants, post-drill. Apart from the building's executive staff and Chief of Protection, no one was informed of the planned evacuation except for fire services—hence the authors referral to it being unannounced. The visitors, the security guards, and building staff on site, were not aware of the planned evacuation. It was a cold evening on the day of the evacuation with a temperature of – 1 °C (30.2 °F) and unexpected snow flurries occurred during the drill. A manual station was activated on the basement level to initiate the first stage alarm (alert tones and announcement only). Although the alarm was acknowledged at the command-and-control centre, the second stage alarm (general alarm/evacuation) was manually initiated nearly five minutes later.

The first stage alarm tones generated over the voice communication system were represented by a bell chime every three seconds. The digital voice communication system activated 15 s after the initiation of the manual station and transmitted the following message in both English and French:

> Your attention please. Votre attention, s'il vous plaît.

> We are currently investigating a potential emergency situation. It is not necessary to evacuate the building at this time. Additional information will be provided if the emergency is confirmed and evacuation is required. Thank you.

> Nous enquêtons présentement sur une situation d'urgence potentielle. Il n'est pas nécessaire d'évacuer l'immeuble pour l'instant. D'autres instructions seront fournies si la situation se confirme et si une évacuation est requise. Merci.

As stated in the transmitted message, the visitors were not required to evacuate and were permitted to roam freely in the building until further notice.

Once the second stage alarm (evacuation tone) was initiated, staff started to indicate to the visitors that they should evacuate, and the tones changed to steady bells. The digital voice communication system activated 12 s after the initiation of the second stage alarm and transmitted the following message:

> Your attention please. Votre attention, s'il vous plaît.

> Due to an emergency situation, all occupants are to evacuate the building immediately using the nearest exit. Please follow the instructions provided by the Building personnel. Please remain calm and do not use the elevators. Thank you.

En raison d'une situation d'urgence, tous les occupants doivent immédiatement évacuer l'immeuble par la sortie la plus proche. Nous vous prions de garder votre calme, de suivre les instructions fournies par le personnel du Musée et de ne pas utiliser les ascenseurs. Merci.

Unlike Scenario 1, the accordion type horizontal sliding fire doors (WON-doors) did not close to create a protected vestibule near the elevator lobbies, separating the atrium space from the floor areas (wings/halls). This closure is triggered when the appropriate sequence of events in accordance with the fire alarm input/output matrix is satisfied, of which was not in Scenario 2. As a result of this, nearly every visitor in the building was able to gain access to the atrium on their respective floor and avoid using the prescribed exits in the posted evacuation procedures. This contributed to 92.3% of the occupants utilizing the main entrance as their exit.

2.5 Scenario 3—Second Planned and Unannounced Annual Drill

A second planned and unannounced evacuation drill was conducted on the same day, one year after Scenario 2. This was the buildings annual drill. The purpose of this exercise was to provide the executive management, security team, and the authors with a means to evaluate the effectiveness of administrative and physical improvements which were implemented throughout the previous year after Scenario 2 took place. This drill offered the authors a unique opportunity to study the effectiveness of modifications to evacuation strategies and physical elements.

Following the planned evacuation drill in Scenario 2, several changes to the Cultural Centre's evacuation strategy were made and adopted (these are summarized in Chap. 5 in greater detail). These changes had focused on the organization and training of designated staff and the adoption of improved egress and exit signage. One notable measure was installing new ISO 7010 compliant "green running person" exit signs with directional arrows directly on the WON-doors. When activated, they would indicate to occupants the direction to the nearest exit. The measure was implemented in direct response to the confusion around the WON-doors seen in Scenario 1, such as visitors forcefully prying open the doors and forcing their way to the atrium. Another change implemented was to lower the exit signage to a maximum of 8 feet above the finished floor. In the previous scenarios they were situated near the ceiling of the buildings (greater than 10 feet above the finished floor). It was recognized that visitors were unable to easily locate or see the previous signage. It was also noted that the theatre's film and sound should be shut off after the first stage alert and the lights turned back on. CCTV footage of the theatre observed visitors remaining in the theatre or entering the theatre as the film continued to be played. Administrative measures included providing high visibility vests for front desk staff, so they stand out more as well as providing a handheld electric megaphone for exterior communication to direct occupants away from the building and prevent newcomers from entering. Procedures for front desk staff were to remove

the "line control barriers" at the first stage alert to avoid blocking the central ramp providing access to the main entrance lobby and that quarterly evacuation exercises be performed with the Cultural Centre staff by rotating through different types of scenarios or holding training sessions that go through the scenarios as a test. Security staff were completing monthly training exercises similar to the Cultural Centre staff and complete written evaluations. Unlike the inclement weather experienced in Scenario 2, the temperature and weather during this evacuation drill (Scenario 3) were fairly mild (9 °C/48.2 °F). In Scenario 3 exit use of the main entrance improved to 34.2% of the occupants using the main exit.

2.6 Summary

This chapter highlighted the data collection methodology which primarily relied on the use of existing CCTV cameras. Scenarios 1 and 2 illustrated significant exit usage of the main entrance, where Scenario 3, after adoption of improved signage and staff training, illustrated a distributed exit of the Cultural Centre as would be expected. All scenarios where data was taken for occupant movement reflect low densities and are considered a free flow movement out of the building at the main entrance.

References

1. A. Cuesta, O. Abreu, A. Balboa, D. Alvear, Alone or with others: Experiments on evacuation decision making. Fire Saf. J. (2020)
2. K.K. Haidet, J. Tate, D. Divirgilio-Thomas, A. Kolanowski, M.B. Happ, Methods to improve reliability of video-recorded behavioral data. Res. Nurs. Health **32**(4), 465–474 (2009)

Chapter 3
Human Behavioural Analysis for Evacuations of a Heritage Cultural Centre

3.1 Introduction

An unplanned and unannounced evacuation event (Scenario 1) at a Cultural Centre observed 73% of its approximate 1730 occupants (41% capacity) evacuate using the main entranceway, despite, code-compliant exit signs, onsite personnel providing instructions and physical barriers meant to prevent the overuse of the main entrance. The remaining population evacuated using the 11 alternative ground floor exits, with no apparent preference of trend. As a result of the unplanned evacuation event, two planned annual drills were used to investigate factors that effected evacuations of Cultural Centres. These unannounced evacuation drills were conducted and held one year apart (Scenarios 2 and 3). The final drill (Scenario 3) was used to evaluate improved evacuation strategies and staff trainings, implemented by building management after the first two evacuation events.

Chapter 2 introduced the scenarios and presented the methodology of data collection. Subsequent chapters will now analyze this data in detail. The aim of analyzing the evacuation events was to (1) develop a baseline for the behaviour and actions of people during the pre-movement and movement stages of emergency egress situations and (2) collect behavioural and movement data to aid the fire safety engineering community with the decision process for egress and evacuation strategies. This chapter describes the exit usage, exit times, and notable behaviours observed during the three different evacuation events.

3.2 Methods of Analysis

CCTV videos of each of the evacuation events were systematically reviewed. The footage was analyzed to determine occupant load, age demographics and exit strategies taken by the evacuees. The age of occupants was separated into five categories (under 3 "Tiny Tots", 3–12 "Kids", 13–17 "Teenagers", 18–65 "Adults", over 65 "Seniors") to match those used by the Cultural Centre's marketing database and ticketing procedures. Each individual was tracked from their original location on the floor area upon initiation of the second stage "evacuation" alarm to their eventual egress of the building. Manual plots have subsequently been adapted following similar notation styles as described by Gwynne et al. [1]. Through the analysis, behaviours of the occupants as they egressed were noted, especially if it was observed among multiple evacuees. CCTV footage taken of a theatre and an atrium in the Cultural Centre was also analyzed for occupant behaviour as the evacuation went on. A full description of the methods of data collection can be found in Chap. 2.

3.3 Scenario 1—Unplanned Evacuation

Based on a systematic analysis of exit footage by the authors, the occupant load was estimated to be 1730 with an approximate error of ± 6. The occupants were further categorized based on estimated age (based on criteria as outlined in Chap. 2). These age categories selected matched those used by the building's marketing database and the same identification metric was used that the building used to classify occupants in each category as in Table 3.1. The distribution of exit usage by the occupants was also evaluated to determine if there was disproportionate use of one exit as it can increase total evacuation times (Table 3.2).

The majority of occupants used the main entrance as their exit route, approximately 72.9% of all occupants. The modern North American building codes (NFPA, IBC, and NBCC), specifically state that if more than one exit is required in a building, every exit shall be considered as contributing not more than one half of the required exit width, including the principal entrances serving as a dance hall or a licensed

Table 3.1 Estimated age distribution of occupants in scenario 1

Age category	Age	Number of occupants	Percentage of occupants (%)
Tiny Tot	0–2	75	4.3
Child	3–12	567	32.8
Youth	13–17	38	2.2
Adult	18–65	941	54.4
Senior	65 +	109	6.3

Table 3.2 Exit usage distribution during scenario 1

Exit reviewed[a]	Number of occupants	Percentage of occupants (%)
Main entrance	1262	72.9
Stairwell 10—group entrance exit (East)	11	0.6
Stairwell A1—exit door (South/East)	14	0.8
Stairwell B—exit door (North/East)	149	8.6
Stairwell C1—exit door (South/West)	5	0.3
Stairwell C2—exit door (South/West)	10	0.6
Stairwell C3—exit door (South/West)	46	2.7
Stairwell D2—exit door (North/West)	8	0.5
Stairwell D3—exit door (North/West)	38	2.2
Stairwell D4—exit door (North/West)	7	0.4
Stairwell E—exit door (East)	58	3.4
Stairwell F—exit door (West)	68	3.9
West hall vestibule exit door (Terrace)	54	3.1
Total	1730	

[a] Exit locations can be inferred from Fig. 3.1. Only exits used are identified

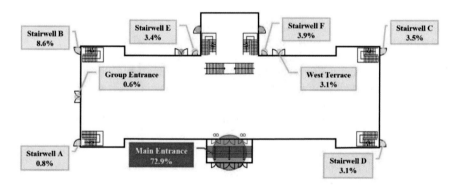

Fig. 3.1 Exit use in scenario 1

beverage establishment. The intent behind these requirements is to limit the probability that an excessive portion of the exit capacity will be concentrated at one location, which could lead to delays in the evacuation to a safe place [2]. During the evacuation, the WON-doors activated, which blocked the access to the atrium from the wings and hall on each floor. This caused confusion among the visitors and staff as neither appeared to be trained to where to exit if they could not exit via the main atrium. Signage was not effective as it was observed that the visitors disregarded these directions and instead were able to force the WON-doors open and from there, predominately used the main entrance.

Table 3.3 Fire alarm event timeline for scenario 1

Time after 1st stage alert (M:S)	Event
00:00	1st stage alert initiated
02:21	2nd stage alarm initiated
02:24	WON-door relay activated, creating a barrier between the wing/halls and the atrium
05:51	First firefighter arrives on the scene and responds to the activated manual station in the vestibule
07:10	95% of population exited building
09:05	The last visitors exit the building through the centre door in the vestibule

Table 3.3 shows the major events by time recorded on the CCTV. The time from when the second stage alarm was initiated to the last visitors exiting the building was 6:44 (M:S).

In addition to exit footage, CCTV footage of the main atrium, theatre, and restaurant café were also analyzed for occupant behaviour. Notable behavioural observations were recorded.

A behaviour that was recorded in all three scenarios, was that when exiting via the main entrance, the majority of visitors used the centre door. This is likely due to columns that support the glass tower, which was added in recent renovations, blocking the side doors of the main entrance as shown in Chap. 1.

In addition, there did not seem to be much urgency for the visitors to evacuate as many were observed waiting in the atrium and watching others leave before exiting themselves. Some of the visitors were waiting for other members of their group, presumably families, as they had been in different areas of the Cultural Centre at the time of the evacuation. Families with young children were seen leaving with their stroller, despite the Cultural Centre's policy to leave it at the freight elevator during an evacuation. The strollers were observed to hinder egress as they needed to be carried downstairs, which slowed down both the family and other occupants as they had to move around them (see Fig. 3.2).

Additionally, several visitors gathered at the parking pay station in the main foyer. The staff in the area did not ask the visitors to leave the building and inform them that payment could be done on the way out of the parking lot.

Video of the theatre showed that after the first stage alert, which was only alerting the visitors to a potential emergency, visitors did not begin to leave. Within the theatre, the current occupants all began to leave at the same time, when the second stage alarm began. While all occupants of the theatre left at the same time, there did not appear to be much urgency as everyone calmly gathered their possessions and groups before leaving. After the theatre was empty, it was evident that the video continued to play despite the alarms. A few minutes after the initial visitors left, a family of four and a single visitor are seen entering the theatre and sitting down.

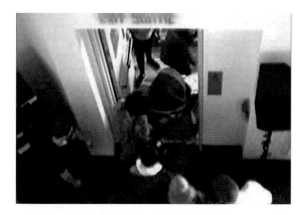

Fig. 3.2 Camera footage showing stroller impeding egress at the stair entrance

There are still flashing lights in the background from the alarm, however, both the family and the single visitor remain in the theatre for almost ten minutes before leaving. As there is no audio, it is unclear if they left due to the alarm or if the film simply ended. At no point did a staff member check to see if the theatre is occupied.

CCTV footage from the café also showed that like the theatre, occupants did not begin to leave until after the second stage alarm, where the announcement explicitly asks visitors to evacuate. However, similar observations to the atrium noted that there was no sense of "real" urgency by the visitors while evacuating as many took time to gather up their belongings before leaving. Staff were observed closing the café entrance once all other occupants had left to prevent others from entering and using the area.

3.4 Scenario 2—First Planned and Unannounced Annual Drill

Based on video analysis of the exits using CCTV, the occupant load of the Cultural Centre at the time of evacuation was 457 (11% of full capacity). The occupants were further divided into estimated age, which appeared to influence the egress time of the occupants. As in Scenario 1, several parents who were accompanied by "Tiny Tots" were noticed to leave the immediate floor area with a stroller, when it is noted in the building's emergency response plan that strollers are to remain in place at the freight elevator lobby during an emergency evacuation. This behaviour hindered the flow of egress as two people are required to lift the stroller downstairs. A number of the senior occupants were seen using handrails to walk down the stairs, some required direct assistance, or some carried on slowly due to an identified mobility impairment (cane, limp) or unidentified mobility impairment. Several parents were also seen carrying their child(ren) in their arms and then using a handrail to steady

themselves when navigating stairwells. In all, approximately 20% of the building's occupants in Scenario 2 required assistance or had their mobility impaired. Table 3.4 lists the population age categories observed in the first planned evacuation and their respective average evacuation times. Exit usage distribution was determined with a focus on the ten exits on the ground floor (Table 3.5 and Fig. 3.3).

Approximately 92% of the visitors during the evacuation exited the building through the main entrance on the 1st floor instead of using one of the six available exit doors nearest to them on the floor space. The inclement weather (− 1 °C/30.2 °F and light snow flurries) during the scenario evacuation influenced the behaviour of the majority of the occupants and resulted in higher than anticipated evacuation times due to a reluctance to go outside and a desire to gather belongings in a cloak room located on the 1st floor near the main entrance (occupants dwelled in landing before the exit). This behaviour has been documented before [3]. This behaviour resulted in 12 occupants returning into the main vestibule up to two (2) minutes after the second stage alarm. Of the 422 occupants who used the main entrance exit, 16 utilized the right (West) door, 11 utilized the left (East) door, and the remaining 399 used the centre door. Occupants predominately used the left door when congestion in front of the central door peaked resulting in 11 users. During peak congestion, a queue at the parking meter (Fig. 3.4) was blocking the use of the left door and only

Table 3.4 Scenario 2 evacuation occupant population by age category

Age category	Age	Number of occupants	Percentage of occupants (%)	Average evacuation time (M:S)
Tiny Tot	0–2	16	5	4:29
Child	3–12	48	14	3:34
Youth	13–17	18	5	3:29
Adult	18–65	252	73	3:13
Senior	65 +	13	4	3:22

Table 3.5 Exit usage distribution during scenario 2

Exit reviewed[a]	Number of occupants	Percentage of occupants (%)
Main entrance	422	92.3
Stairwell 10—group entrance exit (East)	− [b]	–
Stairwell C—exit door (South/West)	10	2.2
Stairwell D—exit door (North/West)	13	2.8
Stairwell E—exit door (East)	6	1.3
Stairwell F—exit door (West)	6	1.3
Total	457	

[a] Exit locations can be inferred from Fig. 3.3. Only exits used are identified
[b] The occupancy and exit contribution could not be tracked through stairwell #10—group entrance doors as the camera footage jumps by 3–5 s in random intervals

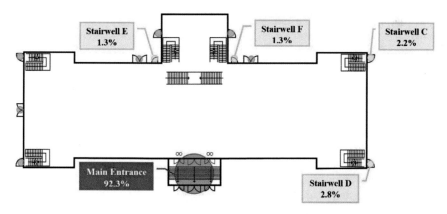

Fig. 3.3 Exit use in scenario 2

Fig. 3.4 Selected behaviours observed after second stage alarm (Left) person taking photos (Centre) dwelling outside near the principal entrance (Right) queue for paying for parking

two users utilized that door. Note, that all 11 users were simultaneously queued in for the centre door and only moved once the first person moved to the door.

During the evacuation, the eight accordion-type horizontal sliding fire doors (WON-doors) did not activate to close access to the atrium on the floor areas. This permitted access to the main entrance on the 1st floor, which may also have contributed to the high usage. Table 3.6 shows the timeline of the evacuation.

Table 3.6 Fire alarm timeline for scenario 2

Time after 1st stage alert (M:S)	Event
00:00	1st stage alert initiated
05:04	2nd stage alarm initiated
05:34	70% of 204 occupants with registered pre-movement times have reacted and began to evacuate the building
09:55	95% of occupants left the building
11:39	Last three occupants exit building

CCTV footage of the atrium, theatre, and café were also analyzed for occupant behaviour. As noted previously, the atrium footage showed most of the occupants who exited via the principal entrance (approximately 92.3% of all occupants) mainly used the centre door as the side doors are visually blocked due to columns. Very few people left via the side doors until there was light congestion forming approximately 7 min into the evacuation, where 32 visitors were forced to wait before being able to leave. Once visitors were unable to leave in a steady stream through the centre door, visitors near the back began to use the side doors to exit more quickly. Once the light congestion had been resolved, people went back to using the centre door. The authors observed that the security staff directed the visitors towards the atrium and in fact removed individuals from exit stairwells to direct them towards the atrium. The visitor desk staff were still allowing people to enter the building when the first stage alert (a type of alarm to alert) was activated. As observed in Scenario 1, there was no real sense of urgency from any of the visitors to evacuate. Several of the visitors (youths) were seen taking pictures ("selfies") after the evacuation message was transmitted. Figure 3.4 illustrates various above behaviours.

In order to allow for the most flexibility with displays, the exit signs are placed quite high in the ceiling space in the floor areas. Visitors were seldom seen looking for the exit signs in CCTV film recordings. In fact, several of the visitors were seen walking with their head down looking at their mobile phones. The time to evacuate for several of the parents and visitors was significantly delayed in order to get their children or themselves properly dressed in coats. This specific behaviour hindered the flow of egress as it was typically done in the foyer near the centre door. Similar to Scenario 1, several parents were noticed to leave with a stroller, when it is noted in the building's emergency response plan that strollers are to remain in place at the freight elevator lobby during an emergency evacuation. This behaviour hindered the flow of egress as two people are required to lift the stroller downstairs.

From CCTV footage of the theatre, the majority of occupants leave together, presumably at the time of the second stage alarm, similar to Scenario 1. However, some visitors remained in the theatre despite seeing others leave and stayed for approximately 5 min before leaving themselves. As observed in Scenario 1, it is unsure due to a lack of audio if they left when the film ended or if there was a different environmental cue. Unlike Scenario 1, a person, assumed to be a staff member, does walk through the theatre after the other visitors had already left, appearing to check if anyone is there after approximately 7 min.

Footage from the café also demonstrated occupants' lack of urgency, as when visitors decide to leave, they do so without any visible urgency, gathering up items and stowing in chairs before leaving. Unlike in the theatre, where multiple visitors leave around the same time, presumably due to the second stage alarm, the visitors leave at staggered times. A staff member partially closed the café entrance and occupants still in the café left soon afterwards.

In addition to the qualitative behavioural analysis, the CCTV footage from Scenario 2 was also reviewed to determine the pre-movement time, as being the time from when the second stage alarm (to evacuate) was activated to when it was "visually apparent" that the occupant decided to evacuate. Visually apparent means

Table 3.7 Summarized pre-movement time (measured after second stage alarm initiation)

Pre-movement time (s)	Percentage of occupants (%)
0–5	17
6–10	18
11–20	15
21–30	18
31–60	20
61–120	9
121–210	3

that there was an obvious twist of the head resulting in the body shifting from its original position to one leading the occupant in the apparent direction of the exit. This represented only the people who could be tracked fully through the building (N = 347). This could be applied as a pre-evacuation time in models to best reflect the behaviours observed. These are presented in Table 3.7.

A custom movement profile for the Cultural Centre occupants was derived from walking speeds observed during Scenario 2 (this was not practical in Scenarios 1 and 3 due to time constraints and insufficient camera angles). The input movement speeds for the evacuation software used is intended to be taken from an uncongested environment. Through reviewing security camera footage, the atrium was selected as the people walking through this area met this criterion. Additional post-processing code was developed to be used in conjunction with Kinovea, freeware, open-source sports kinematics software. With this new post-processing code, it was possible to easily generate movement speeds from the CCTV footage provided by the Cultural Centre.

In regular use, Kinovea can track user-specified objects in video feeds, correcting for lens and angle distortion. However, Kinovea could not directly provide average speeds for an entire population, nor could it adapt to the occasional duplicate frames observed in low-framerate CCTV video. Custom post-processing code was developed by the authors using Excel VBA scripts to determine average speeds for entire populations over the course of tracking, while also detecting and accommodating frame duplicates from the camera footage. The developed script also sorts and categorizes the final average speeds based on the names manually given to the tracked objects within Kinovea.

Dimensions from computer-aided design (CAD) drawings and surveyed measurements taken from the Cultural Centre's tile patterns were used to create a horizontal calibration grid for the input video within Kinovea. This grid was raised to approximate head-level and aligned using horizontal wall tiles as markers (Fig. 3.5). This process was repeated until density increased to the point that few if any occupants could be tracked accurately.

90 occupants passing through the atrium were analyzed for spot speeds. These occupants were not those in congested times and represent unimpeded free flow.

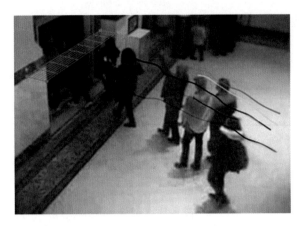

Fig. 3.5 Example of Kinovea with tracking and perspective grid shown on the video footage

One of the acknowledged limitations for determining individual movement profiles and for accurate and complete data collection though this method is that it currently can only be applied to unimpeded and low-density flow as was the case in all three scenarios. Higher occupant densities can lead to greater occlusion and similar tracking targets which adversely impacts data accuracy. Therefore, further studies and additional methods of determining movement profiles and speed should be considered to investigate the effects of impeded flow at greater occupancies. In the same manner, the movement profiles are reflective of the speeds observed near the exit. These could also be more holistically compared to instantaneous speeds elsewhere in the building to ascertain more descriptions of variable travel with different locations and distances from the exit. The authors did tabulate these speeds elsewhere and they are noticeably smaller in value than those tabulated where it was observed that the mean travel speed was 0.51 m/s with a deviation of 0.25 m/s (2.38 m/s max. and 0.10 m/s min).

The population analyzed was composed of parents with children, adults, and youth (combined youth and child). There were not enough seniors nor specifically children in the Cultural Centre's footage to represent a statistically significant profiles and this is in need for future use to instill confidence in the presented movement profile below. The final profile is averaged and summarized in Table 3.8. A brief comparison to Fruin is provided, further contextual discussion is provided in Chap. 4.

The movement profile will be used to verify movement data using two commercial evacuation software(s) in Chap. 4. The preliminary modelling results are explored in Chap. 4. It will also be used to investigate the effects that the architectural renovations to the Cultural Centre may have had on egress.

Table 3.8 Able-bodied profiles for fire drill movement throughout atrium (Computer-vision-tracked)

		Speed (m/s)				
Agent profile	Sample size	Min	Max	Mean	Median	SD
Youth	30	0.6	1.98	**1.19**	1.15	0.25
Adult	30	0.79	1.74	**1.21**	1.21	0.25
Parent and Child	30	0.58	1.69	**1.06**	0.99	0.32
Total	90	0.58	1.98	**1.15**	1.15	0.28
Fruin	–	0.65	2.05	**1.35**	–	0.25

3.5 Scenario 3—Second Planned and Unannounced Annual Drill

The occupant load at the time of the planned evacuation was counted to be 386. Like the previous scenarios, exit distribution by the occupants was determined through a comprehensive analysis of the CCTV footage available at each exit. This scenario followed one year after Scenario 2 and the building management made several procedural changes and modifications to signage as discussed in Chap. 2. Figure 3.6 and Table 3.9 summarizes the exit use in Scenario 3 with further timeline described in Table 3.10.

Unlike in Scenario 2, where the eight accordion-type horizontal sliding fire doors (WON-doors) did not activate to close access to the atrium on the floor areas due to malfunction, every WON-door except for one activated during the Scenario 3. This action created a physical barrier between each of the floor areas and the atrium, which provides access to the main entrance on the 1st floor. In contrast to the desired behavioural outcome, the wing of the Cultural Centre, where the WON-doors did not activate, accounted for nearly 50% of the population that used the main exit as they were provided access to the atrium. The remaining 50% were already located in the central core of the building, which includes the 4-storey atrium.

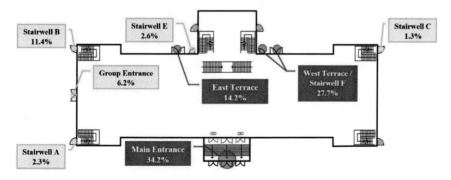

Fig. 3.6 Exit use in scenario 3

Table 3.9 Exit usage distribution scenario 3

Exit reviewed[a]	Scenario 3	
	Number of occupants	Percentage (%)
Café Exit—exit door (East Terrace)	55	14.2
Main entrance	132	34.2
Stairwell 10—group entrance exit (East)	24	6.2
Stairwell A—exit door (South/East)	9	2.3
Stairwell B—exit door (North/East)	44	11.4
Stairwell C—exit door (South/West)	5	1.3
Stairwell E—exit door (East)	10	2.6
Stairwell F—exit door (West)	0[b]	0[b]
West hall vestibule exit door (Terrace)	107[b]	27.7[b]
Total/overall	386	

[a] Exit locations can be inferred from Fig. 3.6
[b] The exit contribution of the West Hall Vestibule was combined with Stairwell F as they both merge together outside

Table 3.10 Fire alarm event timeline for scenario 3

Time after 1st stage alert (m:s)	Event
00:00	1st stage alert initiated
00:16	1st alert message communicated
02:16	2nd stage alarm initiated
02:25	WON-doors activated and started to close on all levels except one hall, occupants are still able to access the main atrium
04:47	WON-doors are all closed
06:35	95% of occupants have exited
13:04	Last occupants exit the cultural centre

The combination of the new "green running person" exit signs installed on the both sides of the WON-doors and clear direction from security staff on each floor area appeared to assist the occupants' decision-making as no one tried to open the WON-doors, as was the case in the first evacuation incident, to gain access to the atrium and exit through the main entrance. The cloakroom remained accessible to the public during Scenario 3. It is hypothesized that it was not a gathering point because the weather was fairly mild, and it was not snowing.

The complete evacuation of the occupants took 10:48 min from initiation of the second stage alarm to when the last person was seen exiting the building. This is not to be construed as the larger percentile whereas 95% of the occupants exited by 6:35 min.

In general, observations from the CCTV footage show that the amount of people exiting through the main entrance was significantly lower than Scenarios 1 and 2. It may be hypothesized to be attributed to the implemented changes such as increased signage and clearer directions from Cultural Centre staff. However, like the previous scenarios, it was also observed that many people did not seem to have to a sense of urgency to leave, as people were observed slowing down in order to talk with others or waiting to arrange their clothing before leaving the floor area or exiting the building. In the CCTV footage, there appeared to be more staff near the exit that were helping and guiding visitors as they left. It was also observed, that consistent across all three scenarios, visitors used the centre door of the main exit the most, and very few occupants used either of the side doors.

It was apparent that some of the visitors noticed the new exit signs on the WON-doors as they looked up and made a noticeable acknowledgement (head nod or looked at and turned right away). Staff also were able to guide visitors away from the WON-doors and to the nearest exit. Like the previous scenarios, visitors were carrying strollers down the main atrium stairs which slowed their egress as well as others. Staff were also positioned outside the main entrance to guide visitors to the appropriate exterior assembly area, in addition to ensuring that no new visitors attempted to enter the Cultural Centre, which was observed in Scenarios 1 and 2.

3.6 Summary

This chapter addressed the analysis of behavioural aspects that were observed during the three evacuation events. Through systematic video analysis of CCTV footage, the exit usage by the occupants was recorded. It found that the majority of evacuees used the main entrance (likely their familiar exit) as their exit route. By contrast, when improved signage and staff instructions were implemented as per recommendation, the percentage of occupants using the main entrance to exit decreased significantly. In addition, while the total time of the evacuation varied between the scenarios, the time from the second stage alarm when occupants were asked to evacuate to when the 95th percentile of occupants have evacuated was similar across all three events. Weather was found to influence the evacuation as occupants were more reluctant to leave when it was cold outside, in addition to stopping to put on winter garments. Across all scenarios, there was a lack of urgency observed by the occupants during the evacuation and a low population density relative to the capacity of the building. This limits discussion to low occupancy scenarios as high congestion and density was not observed.

References

1. S. Gwynne, J. Ouellette, R. Brown, M. Kinateder, Developing a notation for mapping evacuee response, in *15th International Conference and Exhibition on Fire Science and Engineering*, Windsor, UK (2019)
2. D. Drysdale, *An Introduction to Fire Dynamics* (Wiley, Chichester, 2011)
3. L. Bryant, Fire drills and fire protection, in *Second Safety Congress of National Council for Industrial Safety* (1913)

Chapter 4
Architectural Implications for Evacuation Modelling of a Heritage Cultural Centre

4.1 Introduction

There are several architectural elements unique to historic and heritage designated buildings that have an impact on egress, as presented in Chap. 1. Additionally, when heritage buildings are renovated to meet modern code requirements for egress, it is in the best interest of the building to minimize interventions as much as possible to preserve heritage value. The data collected in the study is valuable to the study of emergency egress procedures in heritage buildings specifically and addresses the dearth in modern egress data in heritage buildings raised elsewhere [1]. The implications of the architectural changes made to the building throughout its service life can be evaluated using a validated egress model, presented herein.

The process of model validation involves the comparison of results between the simulated egress scenario and real evacuation data, to ensure the model can recreate real scenarios with accuracy. This chapter presents the egress data from the real evacuation studies collected in the Cultural Centre (Scenarios 1, 2, and 3), the creation of movement profiles for modelling, the validation of these against the real data, followed by the use of the validated and verified model to evaluate heritage and architectural considerations for egress in the building.

The collected evacuation data that will serve as a baseline to validate the egress models against consist of rates of egress and exit usage, and total egress time for each scenario. In contemporary times, egress models can use an agent-based egress simulator to model occupant behaviour through a 3D model of a building or space. Inputs such as movement speeds and other behavioural elements are inputted into the model to determine the occupant behaviour in the simulation. The behaviour and walking speeds (movement profiles) are determined from the collected data, inputted into the model, and the results are compared to determine the accuracy of the model in a known scenario. If the model is able to reproduce the same results as the real evacuation scenarios, the model is considered validated.

© The Author(s), under exclusive license to Springer Nature Singapore Pte Ltd. 2022
J. Gales et al., *Fire Evacuation and Exit Design in Heritage Cultural Centres*,
SpringerBriefs in Architectural Design and Technology,
https://doi.org/10.1007/978-981-19-1360-0_4

With a validated egress model, the model can be used to evaluate the egress performance of buildings without the use of drills. The purpose of the modelling and validation in this chapter is to translate the recorded data into modelling inputs that can recreate the behaviour and egress characteristics observed in the real evacuation events. Through the creation of movement speed profiles, wait times (etc.), and the validation of the model against the real evacuation data, a model was created that can evaluate the performance of the building without the use of additional drills, which like described in Chap. 1, can be costly and require rigorous ethics reviews to organize, and many hours to analyze.

The validated model allows for the evaluation of hypothetical egress scenarios, such as egress in the historic layout of the building compared to the current layout that has been subjected to several interventions. The effect on each of the architectural changes to the building on egress is evaluated at the end of the chapter.

4.2 Exit Usage and Behaviours Affecting Selection

The collected evacuation data is presented herein. Table 4.1 compares the exit usage of all three scenarios. As noted, Scenario 2 had the highest usage of the main entrance at 92.3% whereas Scenario 3 had the lowest usage at 34.2%.

In both Scenario 1 and 2, visitors overwhelmingly selected the main entrance as their point of egress over the 11 other available exits on the ground floor and six connections to alternate exits on the superior floors. In Scenario 3, the exit use was more evenly distributed between the main entrance and stairwells E and F. In Scenario 1, the WON-doors closed, blocking access to the atrium and main entrance from the wings, causing confusion among both the visitors, as well as the security staff. Instead of searching for wayfinding aids in the form of exit signs, the visitors were forced the WON-doors open and gained access to the atrium and eventually the main entrance. In Scenario 2, the WON-doors did not activate, allowing all visitors access to the atrium and main entrance. Security staff were observed guiding visitors towards the atrium and main entrance and in some cases were seen removing occupants from an appropriate exit and guiding them towards the main entrance. However, in Scenario 3, the distribution of exit usage changed, becoming more even which may be attributed to improved signage and staff guidance. When the WON-doors closed, visitors noticed the new "green running person" exit signs with directional arrows pointing towards the nearest exit, and some were observed nodding their heads in acknowledgement. Security staff were also noticed guiding visitors away from the atrium towards the nearest exit, as opposed to the previous scenarios. While the change in exit distribution in Scenario 3 cannot be attributed to only one factor, it is clear that the implementation of improved visual wayfinding signage, physical barriers, and additional staff training, each played a role in the improvement. However, it is difficult to demonstrate how much each implementation contributed to the changes independently or if they were inter-related.

Table 4.1 Comparison of exit usage between scenarios

Exit reviewed	Scenario 1		Scenario 2		Scenario 3	
	Number of occupants	Percentage (%)	Number of occupants	Percentage (%)	Number of occupants	Percentage (%)
Café exit—exit door (East Terrace)	0	0.0	0	0	55	14.2
Main entrance	1262	72.9	422	92.3	132	34.2
Stairwell 10—group entrance exit (East)	11	0.6	– [a]	–	24	6.2
Stairwell A—exit door (South/East)	14	0.8	0	0.0	9	2.3
Stairwell B—exit door (North/East)	149	8.6	0	0.0	44	11.4
Stairwell C—exit door (South/West)	61	3.5	10	2.2	5	1.3
Stairwell D—exit door (North/West)	53	3.1	13	2.8	0	0
Stairwell E—exit door (East)	58	3.4	6	1.3	10	2.6
Stairwell F—exit door (West)	58	3.9	6	1.3	0[b]	0[b]
West hall vestibule exit door (Terrace)	54	3.1	0	0.0	107[b]	27.7[b]
TOTAL/OVERALL	1730		457		386	

[a] The occupancy and exit contribution could not be tracked through stairwell #10—group entrance doors as the camera footage jumps by 3–5 s in random intervals
[b] The exit contribution of the West Hall Vestibule was combined with Stairwell F as they both merge together outside

Research on human behaviour in fire and emergency situations has been identified by many authorities as a critical research need to advance fire safety engineering [2, 3]. This study collected baseline behavioural and movement data however, it has also identified more areas of interest. Further work should be done to investigate the role of the staff as an authority, as they were observed to have a large impact on the evacuation. During the scenarios, it was observed that the staff played a substantial role in the egress decisions of the visitors, from actively directing them to the main atrium in Scenarios 1 and 2, to redirecting them away from appropriate exits in Scenario 2. The role which authority plays in directing evacuations has been identified as a significant factor in decision-making during egress [4], however, further studies should be done to more thoroughly investigate the effect, independent from improved signage.

As per observations associated to the training plans, significant efforts are required to mitigate high security staff turnover to ensure the reliability of this training and consistency in processes during an emergency evacuation. Additional research

should attempt to investigate this aspect across multiple infrastructures as well as the influence on training frequency and staff retention.

4.3 Evacuation Times Observed

Figure 4.1 shows the cumulative number of occupants exiting through the main entrance over the course of the evacuation. All three evacuation scenarios had very different cumulative main entrance use as previously discussed. This figure also demonstrates that the density of the flow of people exiting via the main entrance is different in each scenario, where Scenario 1 has a much steeper curve than both Scenario 2 and 3. Scenario 3 had a slow incline, which could be attributed not only to less people using the main entrance, but also demonstrates that there was not a large rush of people attempting to use the main entrance at the same time. Scenario 2 appears to have a steady slope, indicating a relatively consistent flow of people exiting via the main entrance during the evacuation, whereas both Scenarios 1 and 3 appear to have more varied slopes. When the cumulative number of occupants exiting via the main entrance is converted into a percentage, the slopes were found to be very similar across all scenarios which indicates that the rate of people exiting is similar. This is despite very different percentages of occupants leaving via the main entrance, though, in all scenarios, the occupancy of the building was less than 50% of its maximum capacity—most cases being near 10%. The similar rates of exit imply that the movement of people was mostly unimpeded and there were only a few instances of congestion.

As can be seen in Table 4.2, the total time for evacuations also varied. It is understood by the authors that direct comparisons between the evacuation times are difficult to evaluate as each scenario was unique, with different conditions. Notably, the cold weather and snow in Scenario 2 was observed to have an important impact on the travel path selection and on how quickly occupants left the building as occupants took more time to put on their coats and hesitated to exit into the cold. Another dissimilarity is that the WON-doors operated in Scenarios 1 and 3 however not in Scenario 2 which allowed for an unimpeded access to the atrium area and consequently the main entrance. The time from the second stage evacuation announcement to the 95th percentile of occupants exiting appears to be similar across all three scenarios. As noted previously, in all scenarios, the occupant load at the time of evacuation was always less than 41% of that for the designed exit capacity. This resulted in very few instances of congestion and mostly unimpeded movement.

It was observed in all three scenarios that none of the occupants appeared to have a true sense of urgency while evacuating. Many paused to gather belongings, stopped to observe others before exiting or simply continued to examine displays. A few were observed taking photos of themselves ("selfies") while evacuating. The lack of urgency raises questions on whether the results from the drills would be applicable in an actual emergency. While the first scenario was an unplanned drill, in all three scenarios, there was only the alarms and staff directions acting as environmental

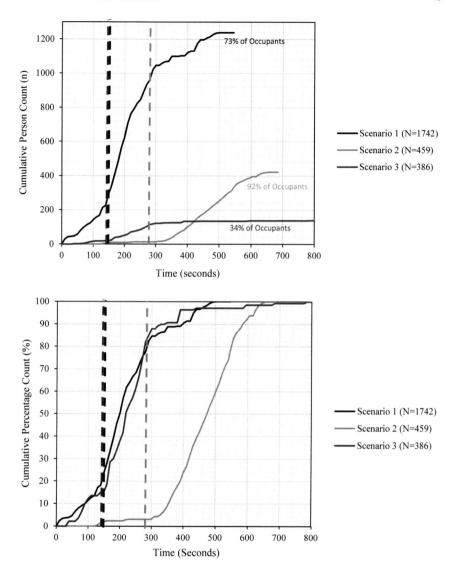

Fig. 4.1 Comparison of cumulative main entrance (Dashed lines denote second stage alarm activation)

Table 4.2 Comparison of evacuation times between the scenarios

Scenario	Time from 1st Stage alert to last visitor exiting (M:S)	Time from 2nd Stage message to last visitor exiting (M:S)	Time from 2nd Stage message to 95th percentile exiting (M:S)
1	09:05	06:44	04:49
2	11:25	06:35	05:05
3	13:04	10:48	04:19

cues for urgency. It is uncertain as to how environmental cues such as smoke or visible flames would affect the urgency and behaviour of visitors during egress. Further studies examining environmental cues would be complex to execute, in part due to ethics considerations to prevent harm to the participants by exposing them to realistically accurate emergency conditions. Previous research has found that, in general, occupants evacuate more quickly during drills, however, the reasons behind the findings have not been investigated yet [5].

To further validate the effectiveness of implemented signage and management changes, future monitoring of the Cultural Centre should be done for instances in which unplanned evacuations occur where populations exceed 41% of total occupancy. These scenarios should be recorded and compared to those reported in this book, particularly for instances where higher congestion could occur and where the occupant to staff ratio is higher.

Behavioural patterns observed in the study, such as those in the main entrance exit use in Scenario 2, begin to verify behaviours also observed in virtual reality experiments where exit choice is influenced by exit familiarity, appropriation, and the behaviour of their neighbours [6].

4.4 Movement Profiles for Modelling

Using CCTV footage of the scenarios and Kinovea software, movement profiles of able-bodied occupants were generated (see Table 3.8 in Chap. 3). The profile presented differs from conventional movements recorded in default settings of evacuation modelling software such as the Fruin commuter movement profiles which are often used today. It should be noted that movement profiles post 1985 are readily available and tabulated, though they lack in certain demographics and infrastructure types [7]. The movement speeds are compared with the general Fruin profile for able-bodied, unimpeded movement on a level surface, provided as a reference [8]. Of note, is that while youth and adults were observed to travel at similar speeds, a group of parent(s) and child(ren) travelled significantly slower. All observed agent profile speeds were calculated to be slower than the general Fruin profile. The slower movement speeds, especially for parents travelling with children, have implications for egress modelling of populations with diverse demographics as the observed speeds are lower than the default profiles commonly used in the majority of available egress and pedestrian movement modelling software.

Research on occupant movement speeds is often presented independently from the demographics they were collected from or are based on approximations instead of observed behavioural data [8]. The movement profile generated from the visitors in this study found that on average, the unimpeded speed of occupants was observed to be lower than conventional movement profiles used and recognized. It is recognized by the authors that further research is required to verify and validate common pedestrian modelling software using this data. The intent of these exercises will be to verify and validate software using the authors' movement (pre- and evacuation)

profiles. It is also the authors' intention to utilize these procedures for future research to validate, verify, and create different evacuation scenarios to optimize the desired outcome based on fire alarm sequence of operation in similar buildings to create adaptive scenario/situation recognition and reactions by each agent based on the parameters defined.

4.5 Evacuation Modelling Validation

In industry, Anon Software A and Anon Software B are both common pedestrian movement software used for evacuation analysis and prediction. They are both driven through similar movement frameworks, and were therefore chosen to analyze the Cultural Centre crowd egress. The overarching goal of this book is to validate movement profiles but not yet explore the software's decision-making benefits or pitfalls. The names of the software used have not been included, as this is not a critique of any particular software. The intent is simply to show in both tools that the movement profile can represent the realistic speed of evacuation seen in reality. The authors restrain from making direct comparisons between the software's underlying mechanics as that is appropriate in future research. In future research these implications may be beneficial to research and development of software.

Software A and Software B have similar construction and input procedures. For both, the model spaces were generated by using the Cultural Centre floor plans as supplied by the building directors themselves and refined by the authors with surveying procedures in order to update certain aspects and incorporate blockages as would be present via exhibits. These floor plans were then transferred into a SketchUp file where elements (inclusive of current exhibits) were then defined in order to appropriately import into the software user space. The model space was then verified to ensure doorways, stairways, obstacles were assigned according to the floor plan to ensure the correct scale. Figure 4.2 shows a floor plan of the Cultural Centre after SketchUp import and imported model in an evacuation simulation software with exhibits shown.

These models used the novel movement profile as defined in previous section by the authors. The validation of the profile was across two evacuation scenarios which reflect the first two evacuations. Note the profile was derived from data from Scenario 2 alone, but would be validated against Scenario 1 and 2. The intent of these validation exercises is to verify the authors' movement (pre- and evacuation) profiles for use in a range of computational egress modelling tools. It is not to validate the decision-making or underlying movement framework in the models.

Scenario 1 shows the modelling of a relatively large evacuation with a population of 1730 occupants that was rationally distributed in the Cultural Centre. This represents a credible occupation on a given autumn day whereas the maximum allowed population of the building is 4184. In Scenario 1, all of the programmed agents were assigned the recorded pre-movement time developed by the authors and assigned tendency of choosing specific exits as were seen in the real evacuation. By

Fig. 4.2 Cultural centre floor plan imported model in simulation with exhibits shown

assigning the exit use we do not attempt to interrogate modelling decision-making on wayfinding. In Software B, the pre-evacuation time in the movement profile section was assigned to all of the agent population by giving a waiting task to all agents. The length of waiting time was assigned in percentage accordingly to Table 3.7 in Chap. 3, denoting the pre-movement times observed in Scenario 2. An exit seeking task was then assigned after agents finished their waiting tasks. The seeking task simulates the exit choosing tendencies of the reality, and the exit seeking task was assigned in percentage following the summarized exit usage rate according to the real events. The model of Scenario 1 in Software A is similarly constructed. Since Software A supports assigning a percentage pre-movement time directly in a table form, with the pre-movement time set up according to only one exit choosing task needed to be assigned to the agents to develop the scenario. The plot of the main entrance exit count comparison between two software was shown by Fig. 4.3 in comparison to the observed evacuation. The main entrance is shown as it represented a population of over 70% who exited in reality. The data presented in Fig. 4.3 represents the average of 10 simulations shown, in line with other studies on historic and heritage buildings [9]. Deviation is also illustrated confirming very small differences between the simulation runs for each software. The appropriate number of simulations to run is described elsewhere [10].

Scenario 2 required additional consideration as in reality the majority of those leaving exited in the main entrance (> 90%) and in addition the occupants were retrieving possessions such as coats during the evacuation (due to a snow event). The population of the model is much lower with 457 agents. The authors analyzed footage of the event and concluded the process of coat retrieval was on average 60 s. In Software B, the agents were firstly assigned the waiting task same as Scenario 1 to simulate the pre-movement time reflective of their position in the Cultural Centre. To

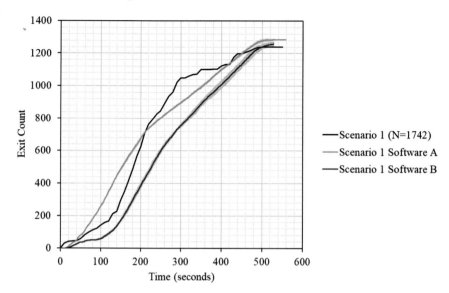

Fig. 4.3 Comparison between the model results and real data for scenario 1 (Main entrance usage only)

simulate the exit choice the cost of route was manually set. The exit cost distribution was tuned close to the distribution recorded in the event. A waiting task initiator was also applied to the atrium floor so that once an agent enters the atrium, the agent will perform a 60 s wait time task to simulate the picking up coat process. After the waiting time, agents will continue their egress. In Software A, an alternative approach is applied. First, all agents had applied a general pre-evacuation time as before in Scenario 1. After the pre-evacuation time, approximately 92% of the population was assigned a task of picking up coat in the atrium. The 92% of population was assigned to seek for the atrium, waiting for 60 s in the atrium and extract from the main entrance. The other 10% of population will perform a normal evacuation that the agent will choose any exit with no restriction. The plot of the main entrance exit count comparison between two software is shown by Fig. 4.4.

In Scenario 1, both the simulation result curves have a trend that generally conforms to the real data curve. Before 100 s, Software B generates a mild increasing trend similar to the real situation, while the curve of Software A is steeper. At 200 s, Software A shows the same trend as the real situation that the exit count increasing rate is slightly decreased, while Software B simulates the decreasing trend after 250 s. Both software results in a similar total main entrance evacuation rate around 70%. The result generated from Software B is wider spread than Software A, illustrated by a wider shaded standard deviation area.

In Scenario 2, both the software-generated result follows the trend of the real situation with a small difference between software. A notable difference between the simulated result and the real situation is the exit count increasing slope. It would relate to a small discrepancy between the ideal movement profile and real population

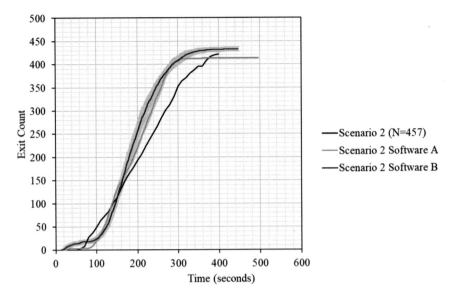

Fig. 4.4 Comparison between the model results and real data for scenario 2 (Main entrance usage only)

movement speed. All modelled trends in Fig. 4.4 suggest a plateau. This is actually not so as there are still a number of slow-moving agents with large travel distances which result in these times appearing extended.

4.6 Architectural and Heritage Considerations for Evacuation Modelling

A range of analyses of the original twentieth century-built building configuration and the building as it is today after significant renovations were conducted using Software B. The purpose was to identify the effects of the architectural renovations on the modern egress of the building and determine their efficacy.

To isolate the effects of specific additions (for example new emergency exits or stairwells), simulations were run with all the additions as the building is now, with each addition tested individually to see their effect on the overall egress time. These models were built based on archival data about the original layout of the Cultural Centre, which were recreated to the best of the authors' research. Where information about architectural changes were not available, the layout was left in modern conditions as to isolate the effects of the known changes to the layout and architectural elements on the total egress time.

The elements that were analyzed specifically were new staircases added in the new tower, ten new exits at the bottoms of existing staircases in the corners and at

Fig. 4.5 Model with and without the columns obstructing two of the three main entrance doors

the back of the Cultural Centre, and columns supporting the new towers located at the foyer (seen in Fig. 4.5). All the elements considered are represented by green icons in Fig. 4.6.

The occupant loading used was the maximum of 4184 for the Cultural Centre to highlight the differences in egress times between the various scenarios with the highest occupancy, with or without certain additions.

The study on the architectural interventions found that the new exits had the most positive impact on the egress, followed by the new stairs, though the most improved egress simulation was the combination of the new stairs and exits. The columns in front of the main entrance doors were found to hinder egress out of the building, lengthening the total egress time.

The columns, or any egress issues related to the main entrance to a building is exacerbated by the fact that most occupants will egress using the main entrance. This is underrepresented by evacuation modelling that doesn't consider that behaviour. When only using movement speeds and pre-movement times in the model, the exit usage percentage is only 14.2% for the main entrance, which is quite low compared to the evacuation data showing a usage in Table 4.1 of 34.2% for Scenario 3, and even higher for scenarios 1 and 2 (72.9% and 92.3% respectively).

An important note about the new stairs, while they contributed to decreasing the total egress time when working with the new exits, they increased the egress time when considered alone. This is due to their placement in the centre of the building, which directed occupants to the main entrance and contributed to a congestion in that area. This congestion was present only in the historic layout where only the original three exits were used, compared to the modern twelve exits. While this scenario of the stair intervention without any other interventions made to the historic layout is only hypothetical, it provides insight into the downside of complicating egress routes on total egress time.

These analyses are part of an important next step in this research and give an idea of what interventions were effective in improving the egress of the structure and

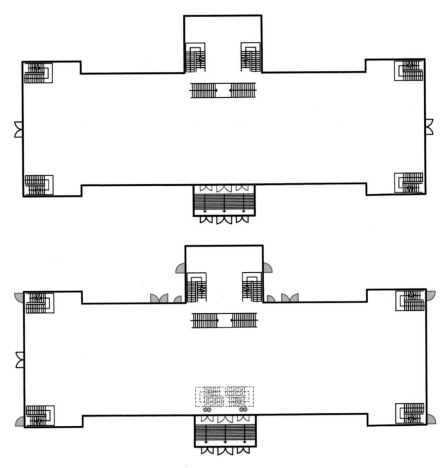

Fig. 4.6 Simplified cultural centre floorplan showing the historic exit and stair locations in black (top), and current layout with additional elements (stairs, exits, and columns) in green (bottom)

which weren't, which is valuable information when working with heritage buildings where minimizing interventions is recommended.

Based on the insights gained from this historical analysis of the egress performance of the building, the egress of the current building could be improved by mitigating the issue of the columns supporting the new staircase. The architectural feature of the columns was the only intervention that had a perceived negative effect on the total egress in modelling time whether isolated in the model or included with the other interventions considered.

4.7 Summary

The exit usage observed in the Cultural Centre showed that the majority of occupants egressed using the main entrance in the first two scenarios, with a decrease in the last scenario predominately due to changes to the signage and staff training, proposed by the authors.

The comparison between Software A and Software B was completed with a model validation regarding movement speeds, as well as a preliminary analysis and heritage considerations. The model validation found similar results between the software when evaluating the main exit use, and only a slight difference of slope between the simulations and the real exit use data. That difference can be attributed to the idealization of the population's movement speeds. The preliminary parametric analysis using default parameters found minimal differences between total egress times with various populations. Overall, Software A and B were verified to produce similar analyses possibly influenced due to their similarity in movement algorithms.

The study on architectural interventions to improve egress, using the validated model, revealed that the new exits were most effective at improving total egress time, and the columns in front of the main entrance doors increased egress time.

References

1. P. Thompson, D. Nilsson, K. Boyce, D. McGrath, Evacuation models are running out of time. Fire Saf. J. **78**, 251–261 (2015)
2. R. Champagne, T. Young, J. Gales, M. Kinsey, Fire evacuation and strategies for cultural centres, in *15th International Conference and Exhibition on Fire Science and Engineering*, Egham, UK (2019)
3. E. Ronchi, Developing and validating evacuation models for fire safety engineering. Fire Saf. J. (2020)
4. B.J. Meacham, Integrating human behaviour and response issues into fire safety management of facilities. Facilities **17**(9/10), 303–312 (1999)
5. M. Kinateder, C. Ma, S. Gwynne, M. Amos, N. Bénichou, Where drills differ from evacuations: a case study on Canadian buildings. Saf. Sci. **135** (2021)
6. E.D. Kuligowski, S.M.V. Gwynne, M.J. Kinsey, L. Hulse, Guidance for the model user on representing human behavior in egress models. Fire Technol. **53**(2), 649–672 (2017)
7. Society of Fire Protection Engineers, *SFPE Handbook of Fire Protection Engineering*, 5 ed. by M.J. Hurley (Springer, New York , 2015)
8. Canadian Commission on Building and Fire Codes and National Research Council of Canada (NRC), *The National Building Code of Canada* (NRC, Ottawa, 2015)
9. G. Bernardini, T.M. Ferreira, Combining structural and non-structural risk-reduction measures to improve evacuation safety in historical built environments. Int. J. Architectural Heritage (2021)
10. E. Smedberg, M. Kinsey, E. Ronchi, Multifactor variance assessment for determining the number of repeat simulation runs in evacuation modelling. Fire Technol. 27 (2021)

Chapter 5
Strategies for Effective Evacuation of Heritage Cultural Centres

5.1 Summary

Chapters 2 through 4 illustrated three different and real evacuation scenarios of a cultural centre. These were analyzed for behavioural and movement data. The resulting analysis being useful to inform building design and policies of existing and new cultural centres, and further address critical research needs in human behaviour and fire.

Information about the visitors, the interactions between staff and visitors, and the type of actions that are undertaken by the staff and visitors during the evacuation process were collected. This information provided a better understanding of evacuations in cultural centres as well as in a demographically diverse population, and acts as a source of data that can be used to help inform egress modelling software.

The first two evacuation scenarios led to changes in signage and staff training to the Cultural Centre by building management. These improvements in the wayfinding signage as well as the additional staff training proved to reduce the use of the primary entrance as the choice for exiting. Staff were observed to play a large role in the evacuation and occupants' decision-making. Movement profiles of visitors were calculated and found to be slower than Fruin speeds, however, further studies will be done to verify and validate these speeds.

Findings from these studies were used to inform the development of evacuation modelling tools which can more accurately represent the behavioural patterns observed and assist the fire safety practitioners in better understanding the limitations of the software we are using to demonstrate that a building is safe for the occupants.

The evacuation models using Software A and B were validated with similarities between the two software with regards to main exit use, and only a small difference of slope was found between the simulations and real exit use data due to the idealization of the population's movement speeds. Both models were verified to produce similar analyses, and the preliminary parametric analysis using default parameters found minimal differences between total egress times with various populations. Future

© The Author(s), under exclusive license to Springer Nature Singapore Pte Ltd. 2022 55
J. Gales et al., *Fire Evacuation and Exit Design in Heritage Cultural Centres*,
SpringerBriefs in Architectural Design and Technology,
https://doi.org/10.1007/978-981-19-1360-0_5

research should expand upon the findings in this book with the inclusion of the third recorded evacuation scenario for validation and more analysis on the renovation of the building and the heritage aspects that influenced the layout decisions.

With a validated and verified model, a range of analyses of the original building configuration and the building as it is today after significant renovations were conducted. The purpose had been to identify the effects of the renovations on the modern egress of the building and determine their efficacy. To isolate the effects of specific additions (for example new emergency exits or stairwells) simulations were run with all the additions as the building is now, with each addition tested individually to see their effect on the overall egress time. These models were built based on archival data about the Cultural Centre. The elements that were analyzed specifically were new staircases added in the new tower, ten new exits at the bottoms of existing staircases in the corners, and columns supporting the new towers located at the foyer.

The occupant loading used was the maximum of 4184 for the Cultural Centre to highlight the differences in egress times between the various scenarios in the worst situation, with or without certain additions. From the preliminary analyses, the new columns in the entrance, as well as the new staircase, had effect on the egress time. The most significant additions in terms of egress were the ten corner exits connecting directly to stairwells linking all four floors and the basement. The governing elements in the emergency egress of the building should still be explored, and the models be further developed with some of the considerations discussed herein and more.

5.2 Study Limitations

There are various recognized limitations to this study. The challenges in collecting and analyzing data are expressed at length in this book. The authors' data sets were generated over years of study. Data sets are slow to collect, analyze and produce particularly due to the often-requested confidentiality of the parties involved, subjectivity in being specific in demographics, and the ethical considerations of collecting the data which limit what can be collected, as was seen in this study.

Although an automated procedure for collecting speed data is presented and greatly enhances the collection time, the method is limited at this time to unimpeded flow.

The improvements seen in Scenario 3 were focused only on the Emergency Response Plans of the specific building, architectural building features and staff (security and management) training. It is critical that the reader recognizes differences in all cultural centres where some changes in signage and management aspects which were made for Scenario 3 may not be fully appropriate nor sufficient to ensure proper evacuation in an emergency for any cultural centre.

The building considered herein uses a two-stage alarm system. The first stage is an alert to stand by, and the second stage is an alarm for all to evacuate. This study did not investigate audio and optimal alarms. The authors have performed a study on the use of voice instructions, presented elsewhere [1].

The data used was collected during evacuation drills as opposed to real emergency scenarios. Conducting evacuation drills as a proxy for real-life evacuations is a common alternative to protect the participants, however, caution must be taken when applying results to actual emergency situations. It is noted that there are ethical considerations when conducting research that monitors human behaviour during evacuation drills, however, the methodology and data for the study was designed to coincide with the required annual evacuation drill held at the Cultural Centre. Due to difficulties in collecting real-life fire emergency data, observations in this study served as an important tool to obtain data on critical behaviours during evacuations and movement profiles of people.

5.3 Strategies Used to Enhance Egress in the Cultural Centre

Between Scenario 2 and Scenario 3, which were differentiated by one year, several changes to the building's emergency plans were considered and adapted. This section discusses these changes that were adopted and/or considered by this specific Cultural Centre for which this study could evaluate. They are provided for reference only as a foundation point to the reader considering their own development or re-evaluation of emergency plans to building changes. These provisions are useful for the reader to be introduced, though caution must be made that they were intended and tailored for this specific Cultural Centre. Other buildings, or similar buildings of the nature of a cultural centre may require different considerations in developing its own unique emergency plan.

Beyond the building's architecture, the role of staff can have a significant influence on the behaviour of occupants of a Cultural Centre. Training of the evacuation procedures was structured and provided to staff. Examples of this training consisted of monthly evacuation exercises and examinations which rotated through different types of scenarios. Training considered written tests to ensure security staff have acquired and retained their responsibilities under the building's emergency response plan. This training included, though not limited to, security staff and management. The number of security provided in each section of the building required consideration of the occupancy of the structure and reflected the schedule for times that are high occupancy. Authoritative and recognizable clothing was adopted by Cultural Centre staff that included the use of high visibility vests. Hand-held electric devices (megaphone) for exterior communication were provided to staff to keep people away from the building and directed to exterior meeting points. Any "Line Control Barriers" were to be removed in instances with first stage alerts.

Consideration was given to the installation of dynamic exit signs and egress path lighting in the floor area that "blink" or "flash" to lead you towards the nearest available safe exit. The use of intelligent active dynamic signage systems is beneficial to be considered. This type of system can determine, through the fire alarm system

or a computer-based algorithm, which exits can be used or not. The unusable exits would be demarked by a flashing X on the exit sign versus a flashing "green running person" for those that are in use. The key factor to using this type of signage is that the occupants can be unaware of the available exits and if the familiarity of the entrance is incorrectly guiding them there, these features can reduce the doubt and assist with the decision to evacuate one way versus the other. Within stairwells, dynamic exit and egress path lighting were installed. Signage was placed no greater than 8 feet above finished floors. With appropriate signage, during the second stage of alarm which indicates to the occupants to evacuate, the use of horizontal sliding fire door assemblies (WON Doors) creates a physical barrier and forces occupants to other exits. Active visual and audio media was turned off and lights illuminated upon activation of the first stage of alert in the theatre, all active visual and audio media was turned off upon activation of second stage alarm. Cloakrooms or ticketing systems were given consideration to be closed off or deactivated.

5.4 The Future of Evacuation Modelling

The research presented herein was motivated to build movement speed algorithms for difficult to study populations. Much of the foundational research of the Cultural Centre herein was presented in key-note at the 11th SFPE Performance based Fire Design Conference in 2020 [2]. That key-note presentation briefly introduced this book in early conceptional form. As part of that research programme, the future of evacuation modelling was explored, and these key points as articulated below are repeated as they pertain to developing further insights in human behaviour and subsequent modelling capabilities which may benefit the architectural design of future and existing cultural centres.

Various practitioners performing pedestrian movement studies collect data for a multitude of projects annually. That data is not easy to release due to confidentiality reasons. The Cultural Centre project provides very specific data and is certainly not applicable to all types of cultural centres (or even cultures), but it does provide very useful contemporary movement sets and behavioural trends with even the potential for anthropometric study. These movement sets align nicely for inclusion in new tabulations as planned in industry. As this data collection for all buildings may be slow, it is paramount that presented data reflect current contemporary demographics and behaviours. In the absence of such, much policy is still being driven, particularly for cultural centres, by movement rules of thumb conducted in the 1970 data collection studies that in some form is still in existence.

The existing trend to capture data consisting of movement speeds and basic anthropometric data fits within the existing movement frameworks and the current modelling tools which exist; however, it tends to negate the complicated decision-making behaviour itself, which can have impact on certain assumptions made and should also be analyzed in the recorded videos as observed herein.

While these current movement models may be of commercial or research value, they ultimately are based on very simplified movement algorithm rules and limited data sets for validation. The majority of these were developed in the early to late 1990s when ASET/RSET was popularized and when computers were limited in processing power and unable to represent complicated movement behaviour. The creation of revised movement Artificial Intelligence and rule-based probabilistic behaviour algorithms will have value in advancing modelling with the ability to lower uncertainty and develop robust behavioural frameworks for circulation and evacuation. In these cases, speed parameters may not be as critical, but rather the actual decision-making process being the most critical as illustrated in this book's case study.

Today, there are more modern advancements and critical thinking to how individuals interact with one another based on more complicated behavioural and decision-making theories, particularly as the field becomes very multi-disciplinary (bringing together psychologists, sociologists, architects, engineers, etc.). There is difficulty in forecasting when these new models will appear that offer new ways to describe evacuation and circulation, however, we do know they will still require both emergency and non-emergency datasets to verify and validate them.

A living database and video analysis tools allow researchers and fire protection engineers to create and share their analyzed datasets in a standardized format, keeping the data used to populate future evacuation models easily accessible and up to date. It also contributes to the preservation of the raw data which was utilized to make data sets in the first place. Many assumptions on the data found in the SFPE Handbook tabulations can be unintentionally used on quick glance without truly understanding if the tabulations are truly applicable to the practitioners' project. There is use in the practitioners having the raw video feeds to decipher the quality of the data and to interrogate how calculations on movement were made to understand their relevancy. For example, there exists little video footage from the 1970 and 1980 movement studies that define the basic movement profiles used in our existing models by default. As we move towards digital living documents, it is the authors' opinion that data sets (video) also be considered for preservation. Too often when considering data sets from the past for which practitioners wish to analyze in greater detail, it comes to be acknowledged that the film was lost with time or never preserved. Although some videos may not be as useful to modern frameworks, future ones may see additional benefit to re-analyze in different contexts, particularly as behavioural data and decision-making frameworks are emerging and being developed in recent years.

References

1. N. Mazur, R. Champagne, J. Gales and M. Kinsey, The effects of linguistic cues on evacuation movement times, in *15th International Conference and Exhibition on Fire Science and Engineering*, Windsor, UK (2019)
2. J. Gales, J. Ferri, G. Harun, T. Young, C. Jeanneret, M. Kinsey, W. Wong, Contemporary anthropometric data and movement speeds: Forecasting the next ten years of evacuation modelling, in *SFPE Performance Based Design Conference*, New Zealand (Mar 2020)

Printed in the United States
by Baker & Taylor Publisher Services